CHESTER AT WAR

MIKE ROYDEN

AMBERLEY

Dedicated to the memory of
the citizens of Chester and surrounding villages
who lost their lives in both World Wars.

First published 2019

Amberley Publishing
The Hill, Stroud
Gloucestershire, GL5 4EP

www.amberley-books.com

British Library Cataloguing in Publication Data.

A catalogue record for this book is available from the British Library.

ISBN 978 1 4456 7524 4 (print)
ISBN 978 1 4456 7525 1 (ebook)

Origination by Amberley Publishing.
Printed in the UK.

Contents

Introduction 4

PART 1: THE FIRST WORLD WAR

Chapter 1 Mobilisation for War 6

Chapter 2 Home Front 19

Chapter 3 Conscription and Objection 24

Chapter 4 Prisoners of War 36

Chapter 5 Victoria Cross Heroes 56

Chapter 6 Armistice and Home Again 78

PART 2: THE SECOND WORLD WAR

Chapter 7 The Phoney War 88

Chapter 8 Western Command 103

Chapter 9 VE Day, Chester 119

 Bibliography 125

 Acknowledgements 127

 About the Author 128

Introduction

I am mindful of this work following hot on the heels of Susan Chambers' *Chester in the Great War*, which this book overlapped during the research and writing. Whereas the former takes a chronological approach dealing with the minutiae of day-to-day life in Chester, in an attempt to avoid covering the same ground about the First World War where possible, I have concentrated on various themes in depth, and would hope this proves a useful parallel study rather than a poor imitation of the former. Furthermore, a book of this size could not possibly claim to be comprehensive about both conflicts and their effect on the city. The same approach applies to the Second World War with reference to the series of insightful essays in *What Did You Do in the War Deva?* which is recommended as a detailed encompassing study of the city during wartime.

PART 1
THE FIRST WORLD WAR

Chapter 1

Mobilisation for War

On Monday afternoon, 3 August 1914, Liberal MP William Glynne Charles Gladstone, grandson of the famous prime minister and the last of four generations of Gladstones to serve in the House of Commons, rose to his feet before the gathered throng. Not in Westminster, or some hurriedly arranged civic platform, but the auspicious annual meeting of the Hawarden Flower Show. No matter, this is where he was going to deliver his final appeal to reason, now that the important chore of awarding the prizes had been completed. The lights were already going out in Europe as he began to speak. Not holding back, he spoke at great length (later covering two full-page newspaper columns!) about the deepening crisis at a village function that would usually demand no more than the obligatory thanks to the participants and all those who supported the event. He went so far as to declare that 'there is only one thing for His Majesty's Government to do under these circumstances, that is, to allow those foreign countries to fight it out by themselves'. His controversial argument was based on the fact that the main protagonists looked evenly matched, and there was, therefore, no need for Britain to become embroiled in helping a weaker partner, while at the same time he implored his audience not to be misled in thinking we had any military obligation to France. A strong and dominant Germany was a far better option than seeing Russia in such a position. Further, he predicted our assistance would enable France to pursue a war of revenge on Germany – which may not have been fully realised on the battlefield, but certainly was five years later at Versailles.

Rarely could a local flower show have witnessed such oratory concerning impending war clouds, rather than the merits of Mrs Tomkins' outstanding begonias. He concluded,

I for one, look to the Prime Minister and Sir Edward Grey to preserve peace in this country. The price of intervention is ... the stagnation of prosperity, and the negation of internal progress, of social reform. A nation's first duty is to its own people. The task that lies before

us of regenerating our own country, of liberating men and women by hundreds of thousands from the degradation of poverty, from squalor and slum life, from the ravages of disease, of ignorance, is a task of such gigantic magnitude, of such paramount necessity and urgency, that it must and will absolve all the energy and devotion and capacity that we can give it. Let other nations wage war furiously, let this country go on in its way steadfastly, unswervingly onward and ever upward towards the ideal which is set before it –the ideal of making this land of ours a happier, brighter and better land.

Chester Observer, 8 August 1914

The vast majority, spurred on by jingoism in the local and national press, the poster campaigns and the rousing pro-war speeches made by politicians, accompanied by retired high-ranking officers and a piano player bashing out 'Rule Britannia' and the National Anthem, had them signing up in their thousands. So much so, it would be another eighteen months before the loss of life had reached such proportions to necessitate the introduction of conscription.

Despite Gladstone's flower show speech, the point of no return on that Monday 3 August had already been reached as he uttered his pleading words. As the war edition of the *Liverpool Echo* was distributed on Chester's streets the previous afternoon, Germany had already presented Belgium with her ultimatum, declaring war on Russia and marching into the French town of Cirey. By Saturday evening, British Naval Reserves had been called up. The British government issued its ultimatum for Germany to respect Belgian neutrality and demanding withdrawal by midnight that same day. The government was invoking the Treaty of London (1839), protecting the right of Belgian neutrality, to which the German Chancellor declared it to be a just *chiffon de papier* (a scrap of paper). In reply, German forces attacked Liege. Orders were issued to the British Army to mobilize, and by 6.30 p.m. that evening, copies of the order were posted on the city gates and at the castle. Within the hour, Territorials and reservists were flocking to the castle to report themselves. As local citizens began to congregate around the castle gates, news began to filter through by midnight – as of 11 p.m. Britain was at war with Germany.

The local press soon carried their condemnation of Gladstone's stance. Their scathing rebuke was damning:

Mr W.G.C. Gladstone M.P, has earned an unenviable notoriety by his astounding speech at the Hawarden Flower Show on Monday. Time was when this gathering was the occasion of famous speeches by another and a greater Mr Gladstone, 'but never aught like this.' As an example of ineptitude, we have not seen Squire Gladstone's speech excelled. We had enough to do with pro-Boers during the South African War, and we sincerely trust we are not to be humbugged by cranks of that class during the present supreme struggle on the Continent. If Mr Gladstone feels strongly in this quixotic direction, he will find himself among kindred souls in the precious body styling itself the Neutrality League. But he has no right to inflict his blundering and prosy opinions upon a patriotic gathering of people at a flower show.

Mr Gladstone, as a Member of Parliament, would have been better employed at Westminster on Monday, listening to the patriotic speech of his leader, Sir Edward Grey, than

in propagating his craven counsels to the villagers of Hawarden. Mr Gladstone, by the way, is Lord Lieutenant of Flintshire, and according to the modern conception of the duties of a Lord Lieutenant, he ought to have been doing what he could for his country in helping to raise and despatch the Territorials, instead of misleading his neighbours as to the real issue of War.

Chester Observer, 8 August 1914

Over the next few days, reports began to flow in of Belgians suffering atrocities at the hands of the Germans. Whatever the truth of the matter, which is usually the first casualty of war, to state a tired cliché, many pacifists were reviewing their stance, and Gladstone was no exception. His pacifist leanings were no idle values, but nor was he a conscientious objector. Within days, his personal struggles were overcome, and his inbred sense of duty prevailed. He had volunteered, initially as a private, but was persuaded to accept a commission as an officer into the British Army on 15 August 1914 as a second lieutenant. He joined the 3rd Battalion, Royal Welsh Fusiliers, and underwent training at Wrexham before going out to France in early March 1915, where he was straight into front-line action by the 23rd. A few days later, his commission was confirmed and he was promoted to lieutenant on 7 April 1915.

Six days later he was dead, shot in the head by a sniper near Laventie on 13 April 1915, just three weeks after arriving in France. Initially, he was buried behind the lines, but special permission was granted by George V for his body to be brought back for internment at St Deiniol in Hawarden, their family church (this practice was never extended to the lower rank and file, and was officially the last time this was done).

The momentum for local mobilisation began to pick up during the days that followed. On Tuesday morning, posters carrying official proclamations were posted on Eastgate and at the Town Hall in an electrified atmosphere, as crowds thronged to catch a glimpse of the ominous message ordering the immediate call up of Army and Navy reservists – and to see what was expected of the local community.

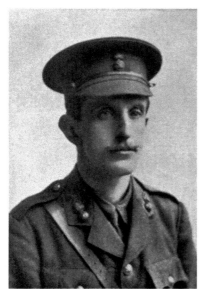

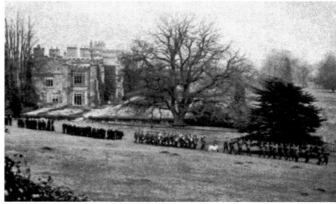

Above: Gladstone's funeral procession leaving Hawarden Castle, Flintshire, Wales, on 23 April 1915.

Left: Lieutenant William G. C. Gladstone, 3rd Battalion, Royal Welch Fusiliers (1885–1915).

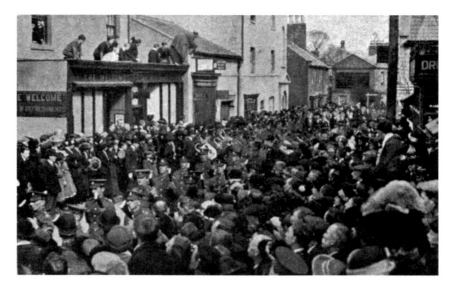

Gladstone's funeral procession passing through the village of Hawarden.

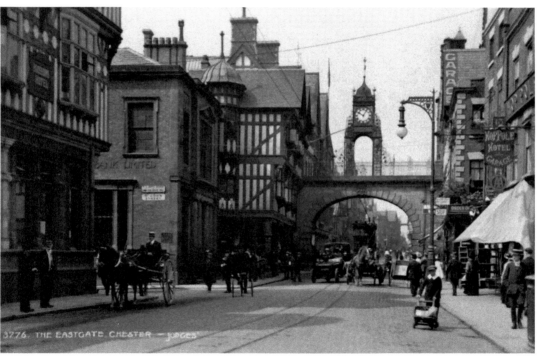

Chester before the war: the Eastgate Clock from Foregate Street, and the corner of Bridge Street.

Orders to the 4th Battalion, Cheshire Regiment, from H. E. Patersall, captain and adjutant, were stark:

All members of the Battalion are hereby warned to report themselves at once at their Company Headquarters in Marching Order with Kit Bags packed. Any man who fails to appear will be treated as a deserter and proceeded against according to the ARMY ACT.

Chester Rows on the corner of Eastgate and Bridge Street, just before the war.

It was further reported that the Duke of Westminster, who was in France at the time of the declaration of war, had arrived safely back in England, and as an officer of the Cheshire Yeomanry had reported himself to headquarters for duty. (The Duke was (as is the present Duke), the major landowner in the region, and resided at the Grosvenor family seat at Eaton Hall just to the south of Chester. He served with distinction in the Cheshire Yeomanry in North Africa, was awarded a DSO and became honorary colonel of the regiment.)

At the outbreak of the war, the British professional army was badly equipped and tiny compared to the conscripted armies on the Continent. It comprised just 450,000 men – including only around 900 trained staff officers – and some 250,000 reservists. While there were confident predictions that 'the war would be over by Christmas', Lord Kitchener, the newly appointed Secretary of State for War, was unconvinced. He warned the government that the war would be decided by the last million men that Britain could throw into battle. Conscription was out of the question, so Kitchener decided to raise a new army of volunteers. On 6 August, Parliament sanctioned an increase in army strength of 500,000 men; days later Kitchener issued his first call to arms. This was for 100,000 volunteers, aged between nineteen and thirty, at least 1.6 metres (5 feet 3 inches) tall and with a chest size greater than 86 cm (34 inches). General Henry Rawlinson initially suggested that men would be more willing to join up if they could serve with people they already knew – people they worked with, or friends and neighbours. This idea was to develop into the units that became known as Pals Battalions. Lord Derby was

the first to put the idea into practice and announced in late August that he would try to raise a battalion in Liverpool comprised solely of local men. He even wrote to local businesses appealing to local employers to let their workers enlist. Within days, Liverpool had enlisted enough men to form three battalions, and by November it was four. So effective was Lord Derby's input that he was nicknamed 'England's best recruiting sergeant'.

Such success inspired other towns to follow Liverpool's lead and form their own Pals Battalions. Universities and schools formed old boys units, clerks formed units from their offices, and factories saw swathes of the shop floor sign up together. Later, there was even a footballers' battalion, which recruited many of the top stars of the day. These eager young men in their 'Pals' units rapidly swelled the army numbers. While there was not a Chester battalion as in the Liverpool example, the vast majority of local volunteers were assigned to the city-based Cheshire Regiment. The city was then the headquarters of Western Command, and the principal recruiting centre for Cheshire. Volunteer troops would soon be enlisted and trained in camps within or around the city, and mass meetings were held at the town hall, plus dozens of communal halls across the county, to persuade men to volunteer for military service. (Western Command was established in 1905 and was originally called the Welsh & Midland Command, before changing its name in 1906. In 1907, Western Command relocated to Watergate House in Chester. In 1938, after a brief stay in temporary accommodation at Boughton, it moved to a new purpose-built neo-Georgian property known as Capital House at Queen's Park in Chester. Commanding Officers during the First World War were Lieutenant General Sir Henry Mackinnon (1910–16), Lieutenant General Sir William Campbell (1916–18), and Lieutenant General Sir Thomas Snow (1918–19).)

In Ellesmere Port, the local press frequently referred to the 'Glorious 514', an initial batch of volunteers heading to Chester, which seems to have been their unofficial 'Pals' joining the Cheshires. There was no Manx Regiment as such, but a great number of Manxmen also enlisted in the Cheshires (along with other regiments such as the King's (Liverpool) Regiment, the King's Own Yorkshire Light Infantry and the Suffolk Regiment), while there was also a Manx Service Company as part of the 2nd Battalion, Cheshire Regiment.

Further north in the Wirral, the Port Sunlight soap works in Bromborough raised around 500 men into the 13th (Service) Battalion, Cheshire Regiment. The numbers had swelled to 700 by 7 September 1914, when a steam train from north Wirral pulled into Chester Northgate station and the latest battalion of the Cheshire Regiment disembarked to march to their regimental home of Chester Castle. This was the Birkenhead and Wallasey contingent, and at the castle they met their comrades from Wirral and west Cheshire, to complete the 1,280-strong Wirral Battalion. The whole battalion, headed by the Port Sunlight Silver Prize Band, with the band of the Chester Church Lads' Brigade in the rear, marched throughout the city, receiving ovations from the cheering crowds all the way. As they swung into the Castle Square, where they were headed by Sir William Lever, Mr Gershom Stewart MP and several other men prominent in the recruitment drive, they were

welcomed by a huge cheer from the large body of recruits positioned opposite the officers' quarters, plus General Mackinnon, Lord Arthur Grosvenor, and the mayor of Chester. Gershom Stewart presented the new battalion to their general, who declared, 'I am very proud to see you all here in such large numbers, all coming as you do from one district of Cheshire. We want every man of you that we can get and I am glad to think that you have turned up in such large numbers.' He then informed them they would be sent to Tidworth Camp for training (Salisbury Plain). From there they would go to Bournemouth and finally Aldershot for final training before shipping out to France.

When war broke out, the Cheshire Regiment was composed of three regular battalions and four volunteer (Territorial) battalions. The 1st Battalion was in Ireland when war was declared, and had been sent straight to France to fight at Mons. Within three weeks there were 800 casualties among the 1,000-strong battalion, and hospital trains full of the wounded began returning to England, many arriving at Chester. However, instead of tempering enthusiasm, this seemed to spur more men to sign up to avenge the defeat of men of their local regiment.

The 2nd Battalion was in India and came home with the Indian Army, landing on Christmas Eve 1914, and after re-equipping was in France a short time later.

The 3rd Battalion, which was in reserve, moved from its Chester Castle depot headquarters to Birkenhead, where it continued to train men for all Regular and Service battalions of the regiment on active service.

With regard to the Territorials, the 5th (Reserve) Battalion was formed in September 1914 to accommodate the rush of recruits who answered the call to arms in the first weeks of the war. They were trained at Chester and then funnelled in drafts to the 5th (Territorial) Battalion, which was already in action in France and Flanders. In January 1915 the unit's title was changed to the 1/5th Battalion, and by 14 February the newly designated unit was in France. The first of the Cheshire Territorials to cross to France, however, was the 6th (Stockport) Battalion, which was there on 14 November 1914. The 1/4th and the 1/7th (Territorial) Battalions arrived in the Dardanelles on 9 August 1915, taking part in the difficult operation around Sulva Bay.

These seven battalions were gradually increased to sixteen front-line Special Service battalions – the 8ths to the 16ths – 'Kitchener's Army' of volunteers, committed for three years, or the duration of war.

Despite the rural dependence on its agricultural workers – who were initially not pressed to enlist – men from the surrounding villages and countryside poured into the city to volunteer for these new battalions, while for those who were more recent migrants, a popular option was to join the battalion from their original home town. Many locals looked to their national allegiance and headed for Wrexham to join the Royal Welch Fusiliers.

There was a variety of other regiments that local men were assigned to, including the Labour Corps, the Royal Engineers, the RAMC, the Royal Field Artillery and the Grenadier Guards, while others joined regiments where they had a family or ancestral connection.

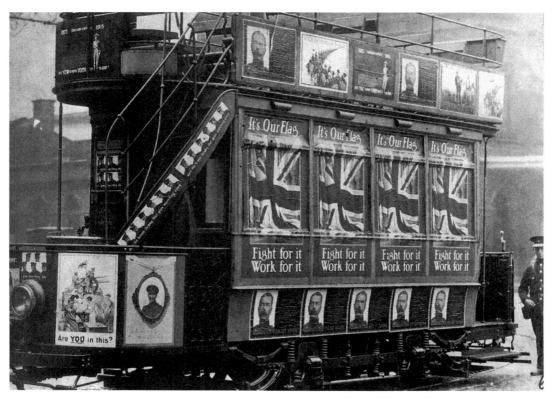

Tram en route from the station to the castle covered in recruitment posters (1915).

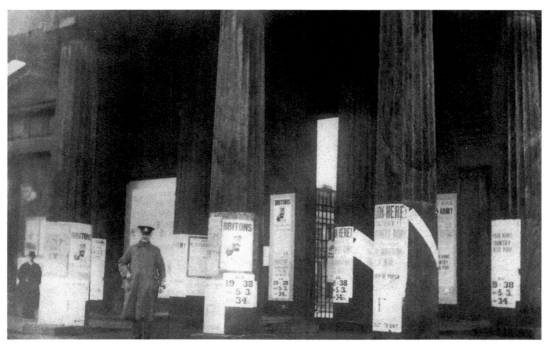

Recruitment posters on the entrance to Chester Castle.

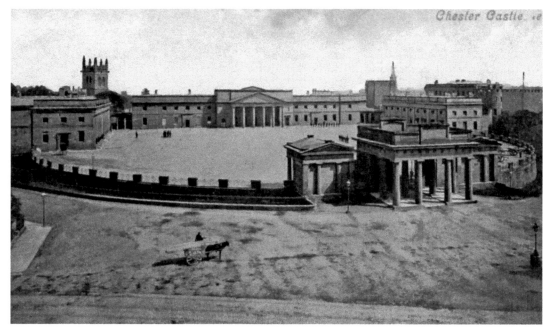

Chester Castle, *c.* 1910, the home of the Cheshire Regiment.

The entrance to Chester Castle today. (Lewis Royden)

As the men continued to enlist in their thousands, it was not an uncommon sight to see the streets of Chester crowded with men, arriving from all parts of the county, to get kitted out at the Castle Depot, and be posted to their allotted billets throughout the town for the night. The authorities were unable to find billets for all, and hundreds of these young men lay on the Castle Square, the Roodee, or about the streets.

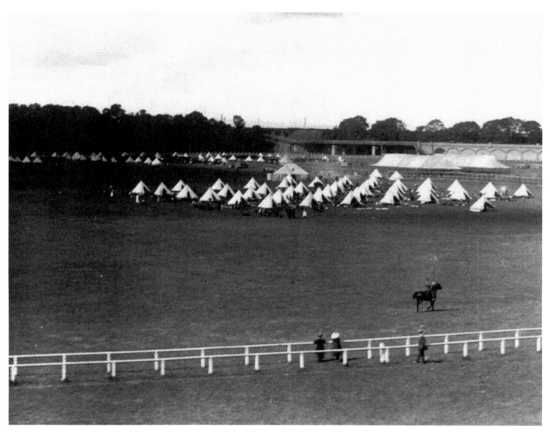

Army camps on the Roodee during the First World War.

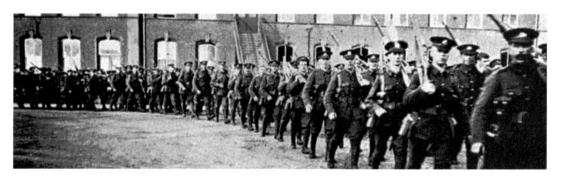

The 1st Battalion, Cheshire Regiment, leaving Northern Ireland for the Western Front. (F. A. Simpson)

The Roodee, closed to the general public, was now a hive of activity, and the walls above were frequently lined with onlookers eager to watch the formation and drilling of troops, the construction of a tented camp and the constant arrival and departure of supplies. Horses were brought in their dozens. Many of those used for parade purposes were too light for the demands of the battlefield and farms throughout the county were scoured for suitable animals, with the going rate to compensate farmers varying between £30 and £40 per head.

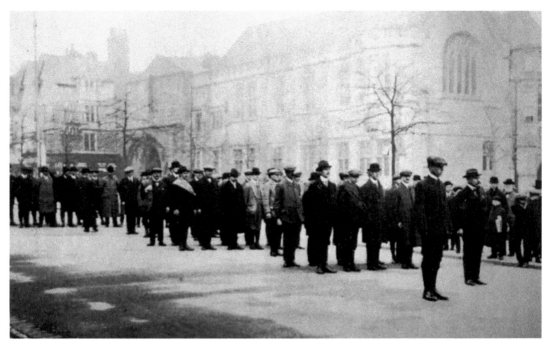

Chester Volunteers (Home Defence) on the Market Square outside the Town Hall. (F. A. Simpson)

Chester Volunteers (Home Defence) on a route march at the junction of Northgate and Eastgate Street. (F. A. Simpson)

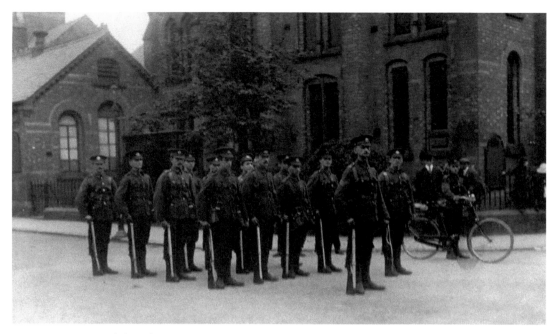

A company of the 5th Battalion, Cheshire Regiment, outside the Drill Hall, Volunteer Street/Albion Street. (Chester History and Heritage)

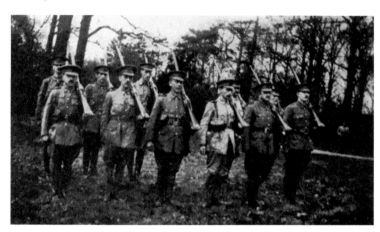

Cheshire Volunteer Training Corps undergoing squad drill in Eaton Park. (F. A. Simpson)

However, those who could not sign up, for whatever reason, were still keen to be involved. As early as the first week of the war, several villages near to Chester were reporting the ad hoc formation of military groups for drill and defence – a prototype Dad's Army – which would soon evolve into a nationally regulated order.

In Mollington and Saughall, fifty-two men had signed up for drill practice and other forms of training, led by a former Army reservist even before war was declared. They were swiftly followed by the men of nearby Upton, while in Farndon village, just south of city on the banks of the Dee,

FARNDON MEN DRILLING

A meeting having been called in the village to consider what could be done to help during this serious time, it was decided that men upwards of 18 years of age should enrol their names and go through a course of drill and rifle exercises and miniature rifle shooting. The first drill took place on Tuesday evening. Twenty-four men had enrolled up to then, and others are expected to enrol on Friday evening, at the next drill. It is possible they may receive instruction in ambulance work as well. It behoves every man to turn up for a little drill and learn to handle a rifle. The ladies in the village are busy sewing, making clothing, etc., for wounded soldiers. Collections on Sunday for the relief fund realised £30. Several horses from this neighbourhood have been bought for the Government at an average price of £40. Farmers now busy with their corn and potato crops are not suffering from any scarcity of labour.

Chester Chronicle 22 August 1914

This locally raised and deployed 'Dad's Army' had wasted little time in becoming organised, and the small village militias were soon absorbed into the newly created Chester Civilian Association. However, it would not be until 29 February 1916 before such units across the country were officially recognised by the government and renamed the National Volunteer Force for Home Defence. Nevertheless, Cheshire can rightly claim to be the first to muster a volunteer movement, beating London's men of Wandsworth by several days. Well before government recognition, the Civilian Association became part of the newly organised Cheshire Volunteer Force, which now had membership and units across the county amounting to 10,000 men, with Chester having the largest contingent of 1,000. No doubt Cestrians slept a little easier knowing they had a fine force of thirty-five to fifty-five-year olds (and more in their sixties and seventies), defending the city.

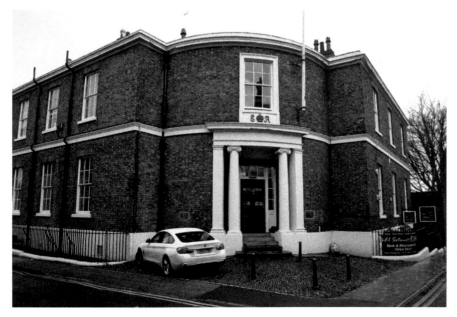

Watergate House, Western Command HQ. (Lewis Royden)

Chapter 2

Home Front

By the end of that first week in August, the government had passed the Defence of the Realm Act (DORA) to 'secure public safety', which became law on 8 August 1914. Several revisions later, the Act gave the government unprecedented powers to intervene in people's lives, enabling them to regulate almost every aspect of the Home Front. Factories, workshops and resources could be requisitioned and utilised to contribute to the war effort. Curfews could be imposed, and censorship of newspapers and publishers was introduced. Suspects could now be imprisoned without trial, and there were now severe restrictions on movement, while discussion of military matters in public became a serious offence. Trial by courts martial, for example, was now authorised for anyone contravening regulations, which were deliberately vague; 'to prevent the spread of false reports, or reports likely to cause disaffection to His Majesty', while almost anyone could be arrested for 'causing alarm.' People were forbidden to loiter near bridges and tunnels, as their actions could be deemed suspicious. Conditions of work were strictly controlled, and a blackout introduced in certain towns and cities under threat from aerial bombardment.

Under DORA, 'British Summer Time' commenced, a measure that is still in practice today. Opening hours for pubs were cut and closing time brought forward – all public houses and hotels were to close at 9 p.m. instead of 11 p.m. Soon beer was watered down, and in an attempt to reduce consumption, a non-treating order was even introduced to prohibit patrons from buying rounds for fellow drinkers, all designed to improve the work ethic. The no treating order was taken very seriously, and local watering holes came under scrutiny, with several prosecutions resulting. Police even resorted to disguise, such as wearing labourers' clothes or even dressing up as anglers complete with tackle, to sit unnoticed in public houses, observing unwitting customers 'getting a round in'.

The Aliens Restriction Act was introduced the day after war was declared, aimed at controlling foreign 'enemy aliens' already settled in Britain, particularly Germans.

This Act, combined with DORA, severely restricted the movement and civil liberties of non-British-born subjects (even naturalised citizens who had resided in the UK for decades). They were required to register with police, obtain permits if they intended to travel more than 5 miles, and were prohibited from entering certain areas. More than 32,000 would be held in internment camps, but the Act also made provision for their deportation, and many were repatriated. Each local area was expected to set aside some sort of provision for detainees. The large engineering and boilermakers' plant formerly owned by Willans & Robinson Ltd, lying disused since 1910 on the banks of the Dee between Sandycroft and Queensferry, was immediately taken over by the authorities, and within a few days around 300 German prisoners of war were interned there. Guarded by a company of the 5th Battalion, Cheshire Regiment (Territorials), the prisoners comprised those formally taken in custody as prisoners of war, and others (from the larger towns in Lancashire and Cheshire) detained as they had failed to find anyone to vouch for them under the terms of the Act. It remained in use only until May 1915, when it was again requisitioned and put to use as HM Factory Queensferry, a munitions works, producing gun cotton, TNT, MNT and 'tetryl', with an associated works at nearby HM Factory Sandycroft. The German prisoners were transferred to the Isle of Man.

In the first few days of war, banks closed temporarily to prevent a run, and £1 and 10s notes were issued to protect the gold supply, but doors reopened on the 7 August. Nevertheless, the public were rattled and panic buying took hold, resulting in basic supplies including tea, sugar, butter, and bacon doubling in price, although this was short-lived as the authorities were quick to reassure the public that all such measures were unnecessary. Despite this, a number of Chester stores were pressed to close their doors at certain times each day, both due to the dwindling stocks and the fact that a majority of shop assistants were Territorials and had reported for duty.

As the war progressed, however, the economy was seriously affected by the U-boat threat on shipping, and as food and essential supplies diminished, hoarding and panic buying became common. Agriculture was also hit by the loss of labour and horse power at the Front, and by January 1918 the government had no alternative but to introduce rationing. Potatoes were often in short supply and sugar was often difficult to get hold of. Consequently, sugar was the first to be rationed and this was later followed by butcher's meat. The idea of rationing food was to guarantee supplies, not to reduce consumption. This was successful, and official figures show that the intake of calories almost kept up to the pre-war level. The local press constantly pushed the message of thrift and frugality, frequently devoting extensive column inches to advice in parsimony, alternative recipes when certain ingredients were in short supply, and the best use of coal. Despite the hardships at home, there were regular collections and contributions for the food and supply parcels being despatched to the front. There were frequent letters home from the soldiers, both in the front line and prison camps requesting particular items that were in desperate need.

The distressing scenes of war witnessed by the doctors and nurses at the front soon started to become more apparent to those at home when vessels carrying the

wounded began to arrive in the Mersey. Trains constantly steamed into the local main line stations also bringing home men for treatment in the local hospitals. This was in the days before the NHS, and many workhouse infirmaries such as St James's, the Chester City Hospital, were commandeered for the purpose, while local mansions such as Eaton Hall and Carden Park were also utilised. In addition, at the outbreak of the war, the British Red Cross and the Order of St John of Jerusalem combined to form the Joint War Committee. They pooled their resources under the protection of the Red Cross emblem. As the Red Cross had secured buildings, equipment and staff, the organisation was able to set up temporary hospitals as soon as wounded men began to arrive from abroad. The buildings varied widely, ranging from town halls and schools to large and small private houses, both in the country and in cities. The most suitable ones were established as auxiliary hospitals, which were attached to central military hospitals, which looked after patients who remained under military control. There were over 3,000 auxiliary hospitals administered by Red Cross county directors.

In many cases, women in the local neighbourhood volunteered on a part-time basis. The hospitals often needed to supplement voluntary work with paid roles, such as cooks. Local medics also volunteered, despite the extra strain that the medical profession was already under at that time. The patients at these hospitals were generally less seriously wounded than at other hospitals and they needed to convalesce. The servicemen preferred the auxiliary hospitals to military hospitals because they were not so strict, they were less crowded and the surroundings were more homely.

Oakfield Manor was initially used to house Belgian refugees before casualties began to be transferred from Eaton Hall (now the mansion house in Chester Zoo).

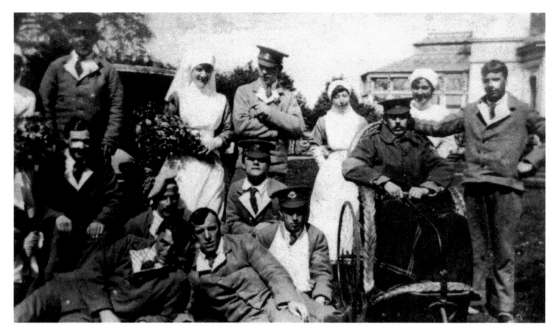

Hoole Bank Military Hospital during the First World War.

In the first week of the war in Mollington Hall, the lady of the house, Mrs T. Gibbons Frost, formed a detachment of Red Cross nurses with a local doctor drafted in to act as instructor. Meanwhile, on Friday 7 August, a meeting of the commandants and other officials of the local detachments of the British Red Cross Society was held at the Grosvenor Hotel in Eastgate, where deployment plans were drawn up for the local nurses who had volunteered their services. In Upton, Oakfield Manor was converted for hospital use and began to receive the men initially sent to Eaton Hall (in 1930, Oakfield was purchased by George Mottershead, where he would live with his family while creating Chester Zoo). A short distance from Oakfield was Hoole Bank House (later the Hammond School). On 15 August 1914, the owner George W. Hayes, who had vacated the property and had moved to Basingstoke, offered the building, complete with its domestic staff, to the Red Cross to use as a hospital for wounded soldiers and sailors, and even paid the expenses for its conversion.

Whenever a trainload of wounded arrived, the limited number of ambulances (many being at the front) were deployed for the stretcher cases, while local people freely lent their motor cars to convey the walking wounded. The Voluntary Aid Detachment's, Red Cross nurses, and ambulance crews all worked tirelessly to alleviate the situation. The men arriving at the hospitals were not necessarily from the same area, and they would be despatched to whatever accommodation could be found at a time when resources were extremely stretched. Nevertheless, there was much support from the local communities in the form of gifts and entertainment. Various forms of specialist care were increasingly required, dealing with the huge increases in the effects of gas, trench foot, loss of limbs, burns, mental scarring, and

the need for prosthetics. Complaints such as trench foot are now synonymous with the conflict, but a soldier was five times more likely to contract VD, which placed extra strain on hospital resources. At any one time there was the equivalent of an army division lying in bed infected with a sexually transmitted disease.

For those reliant on the local newspaper for news from the front line, depressing accounts of further losses continued to appear, although editors were also mindful to include more upbeat news of the soldiers in its sanitised pages to boost morale. Paradoxically, the reportage in war magazines was completely different, as their readership wanted to see what was happening in fairly graphic detail. *War Illustrated, The War Record, Illustrated London News* and the *War Budget* were all freely available. An important source of news for those at home was the cinema, where films like *The Battle of Arras, The Defence of Verdun*, and most especially *The Battle of the Somme* were being shown. The latter was premiered on 10 August 1916, only a month after the start of the battle, and showed very graphic detail of trench warfare with scenes of 'going over the top' and dead and wounded British and German soldiers. The film was very successful, selling over 20 million tickets in the first six weeks alone.

Some British citizens, especially on the east coast, were now experiencing a new type of warfare for the first time – the threat from the air. Although the Chester area was unaffected, the attacks were exploited by the British government to increase emotional feeling against the enemy. After several devastating raids on the east coast, the rallying cry of 'Remember Scarborough' and 'Baby-Killers' became common, and the raid was used as propaganda to encourage enlistment, with numerous posters appearing across the country showing homes destroyed and casualty figures.

Following the Zeppelin raid over the Midlands on 31 January 1916, the local authorities acted very swiftly to introduce new air-raid regulations. By the end of the week – invoking the Defence of the Realm Act – a new Lighting Order was put into operation, and those flouting the law for not screening lights on vehicles or in homes, or for not extinguishing outside lights, were frequently brought before the Chester courts and fined.

Chapter 3

Conscription and Objection

Despite the fact that over 3 million men had volunteered in the first stages of the war, the immense losses meant that the supply of recruits was not enough. When the war started, the British Army had a strength of around 710,000 men including reserves, out of which there were approximately 80,000 regulars ready for action. By January 1915 a million men had enlisted from a total of 5.5 million of military age (with around half a million more reaching the required age each year). By the end of September 1915, the enlisted figure had risen to 2.25 million, while 1.5 million were officially in reserved occupations.

Despite attempts to raise further numbers through registration schemes, by the end of 1915 it was clear that the numbers of volunteers were not enough, and as an inevitable consequence, the government decided to introduce conscription in January 1916. By the terms of the Military Service Act, single men between the ages of eighteen and forty-one were liable to be called-up for military service, although they could be exempted if they were widowed with children, or ministers of religion. Conscription started on 2 March 1916. The promise that married men would not be conscripted did not last long and the Act was extended to include them on 25 May 1916. The law went through several changes before the war's end and eventually, as the casualties mounted, all men up to the age of fifty-one were being conscripted. By the end of the war, almost a quarter of the male population of Britain and Ireland had joined up, a total of over 5 million men. Of these, 2.67 million were volunteers and 2.77 million were conscripts.

However, the patriotic enthusiasm that marked the beginning of the war was giving way to weary grief as more and more families lost sons, brothers, fathers, fiancés and husbands. There seemed no foreseeable end to the war once supposed to be 'over by Christmas'. Exemptions for reasons of health, demands of home, work or work of national importance were included, as was a clause for conscientious objection, inserted to neutralise some opposition. Civil servants who refused to be conscripted on grounds of conscience had their pension rights cancelled.

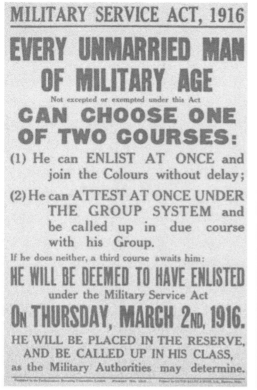

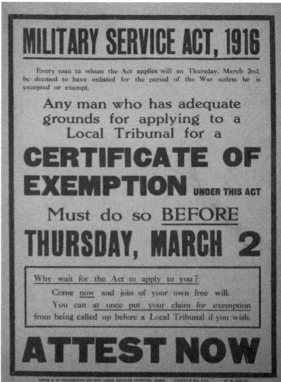

Above left: Military Service Act 1916.

Above right: Exemption from service poster, 1916.

Following the Conscription Act of 1916, many individuals applied for exemption and the Military Service Courts were soon occupied with a myriad of local appeals. Three types of tribunal were formed to hear the appeals. Firstly, local tribunals were appointed by the Local Registration Authorities designated under the National Registration Act 1915. They dealt with attested and conscripted men. Recruiting officers or other military representatives were entitled to attend any hearing and to question applicants.

Secondly, Appeal Tribunals were appointed by the Crown, and thirdly there was a Central Tribunal based in London. Conscription caused real hardships for a great many of the working class, and the pages of the local press frequently revealed many cases where it had brought resignation, anger and despair to many homes.

Under the Military Service Act of Cheshire, which included the county boroughs of Chester, Birkenhead, Wallasey and Stockport, the Cheshire Appeal Tribunal was formed by early March 1916, and consisted of a panel of fifteen local judges and magistrates.

The Chester Tribunal began to meet regularly in the Town Hall Assembly Rooms, usually with the mayor presiding. As hardship increased through the summer of 1916, the majority of cases heard were from those whose workplace or business was already under pressure from loss of staff, and would find it near impossible

to function if more men were lost to conscription. In most cases panels were sympathetic, often granting three month's extension, with conditions attached, such as joining the local defence volunteers, or working in munitions. Sometimes even that was set aside. A Chester coal merchant, who was applying for his son, aged thirty-three and a partner in the business, stated that he had four sons serving in the army, and this was the only son and the only regular worker he had left. They were in a terrible state due to the shortage of labour. He was granted four month's temporary exemption. The mayor asked the son whether he had time in the evenings to drill with the volunteers, to which he replied he was carrying bags of coal all day and was too tired when he got in. His father interjected, 'He carried four tons of coal yesterday. He had no man to go with him'. The mayor replied, 'I think we can leave him. The firm have done their duty well.'

It was clear acknowledgement that when genuine hardship presented itself, together with the fact that the city still had to function, common sense often prevailed and their impatience would be reserved for those they perceived as 'shirkers'.

The local Chester tribunals were kept busy, and the national picture was reflected in the cases heard. Many were from local farmers who, already short of manpower, were expected to maintain food supplies while more of their labourers were called up. Meanwhile local debate raged on about the suitability of women taking their place on the land, which was constantly hampered by those who felt women were wholly unsuitable and without sufficient strength for the demands of daily farming. Tribunals had little sympathy, and most appeals were swiftly dismissed, while the move to provide 'Land Girls' was well under way.

Nevertheless, it was soon realised that the work of some of the tribunals was reducing farm labour to drastic levels. At a meeting of the Chester Tribunal at Chester Castle on 18 May 1916, the Board of Agriculture sent along their representative, Mr W. McCraken, to bring to the notice of the tribunal part of a speech made by the prime minister to the Commons a few days earlier:

> I can only repeat with emphasis that the Government hold the view that maintenance of the highest possible output of home-grown food supplies remains a national object of the most essential nature, and that labour, which is essential and irreplaceable, should be retained on the land for this purpose. The military representatives and members of tribunals should be in possession of regulation and instructions which should ensure the carrying out of this policy.

Others appealed on religious grounds, mainly as pacifists, although one case heard of an appellant who could not exist on army food as he was a vegetarian. Each case did hear some discussion and argument, with the panel members often impatient, lacking sympathy and keen to trip up those before them. This exchange is a sample, although rather unusual, as where most appeals were based around one factor, such as an essential occupation, this appellant was throwing all his cards down hoping one would turn up trumps; his reasons including supporting his aged parents, his debilitating illness, the impending loss of his client base, the loss of his job, the loss of his savings and his religious convictions.

CONSCIENTIOUS OBJECTORS BEFORE RURAL TRIBUNAL

Appearing before the Runcorn District Tribunal at the Workhouse, Dutton. was an insurance agent from Norley, who said,

'I have a conviction that war is wrong, and that it is a wrong thing for a man to take away from a man that which God alone can give – life. I can serve my country better in the present crisis by encouraging people to save their money, than I could if placed in the army. My employers cannot get agents at all now, and would have great difficulty in finding a substitute for me. I am the sole support for my aged parents (68), who are broken down in health and penniless. If I were taken away from them they could not exist, as I have to find money for the landlord, rate collector, and everything. That is why I am still single, I have not been able to save much: the little I have, was saved some years ago, and if I were compelled to join the army I should lose this and also my life policies, which would assuredly lapse. I have worked up a good insurance book, which I should lose if I go away, as my employers cannot guarantee the same position if I return. Rheumatic fever has ruined my life and made me absolutely unfit for any other work other than that in which I am engaged. There are days when I cannot do anything at all.'

The Chairman: Is there anything you want to add to that?

A member: There's something he wants to take out. (Laughter).

Appellant said he was willing to take up work of national importance, such as agriculture, which is skilled.

The Chairman: Supposing you had got no parents and no insurance book, you would be willing to join the army?

Appellant: No

The Chairman: Why not?

Appellant: Because my conscience would not allow me to. I am a member of the Primitive Methodist Church, an organist, and a Sunday School teacher, and for years I held that war and militarism are opposed to the teaching of Jesus Christ, whom I serve.

The Chairman: Are you connected with any other religious body except the Primitive Methodists?

Appellant: No.

A member: What would you do if a German attacked you here?

Appellant: I would not defend myself to the extent of killing him. I would disarm him.

How would you defend yourself? – By taking his arms off him if I possibly could.

Colonel Pilkington: You would very soon be dead. (Laughter).

A member: Where would he be while you were doing it?

Appellant: It would be on his conscience if he took my life.

The Chairman (Mr C. E. Linaker): You are quite willing to take the privileges which the country gives, but you are not willing to strike a blow in defence of them?

– I am not willing to take a life.

The Chairman: You're in the wrong country.

The Rev. Geo Emmett, Primitive Methodist Minister, Northwich, who accompanied the appellant, said that the appellant had held his present views for at any rate nearly four years.

Asked how he knew this, Mr Emmett replied that they had discussed matters of war, peace, and politics during the war.

The Clerk: But you didn't discuss the war until war broke out?

Mr Emmett: We discussed war and peace both before and after.

Mr Chairman: Have you agreed with him?

Mr Emmett: On some things. I don't know how he stands in relation to the origin of the present war, and how far he would attach blame to this country, or to Germany and Austria.

In reply to one of the members, Mr Emmett said that while the church in general had accepted the view that the present war was just, the general teaching of the Primitive Methodist Church was that was contrary to the spirit of the teaching of Jesus Christ. He was not there to argue the case, but to affirm that to his personal knowledge, the appellant had held his present views on war for some time.

The Chairman: Are you opposed to saving life?

Appellant: Yes, in a military capacity.

The Chairman: Then you wouldn't do anything to save wounded soldiers?

Appellant replied that he could not pass a wounded soldier without rendering assistance. He would not, however, join the RAMC or the ASC if it involved taking the military oath.

The Chairman: I am very sorry for you.

The Clerk elicited from the appellant that he filled the domestic and business grounds of the appeal in first, and afterwards added his conscientious grounds at the top of the form.

The application was not allowed.

The Chairman: You can appeal to the Higher Tribunal. Dismissed.

<div align="right">Chester Chronicle, 25 March 1916</div>

Prompted by similar reports in the press, this wife of a serving soldier was reflective of the growing anger and bitter resentment felt towards men 'not doing their bit' whatever their argument:

A WIFE'S DUTY

Sir, I have been reading letters about the objections of the attested married men, and I think it is absolutely disgusting. Why, if they are loyal British subjects, don't they answer their country's call in her hour of need? I don't say there are not a lot of single shirkers left yet. There are (more's the pity); but why should a married man make himself look a coward on account of them? It is a wife's duty to encourage her husband to go, and not show the white feather. Then when all's over and the war's won (by the Allies), she will feel proud of him.

My husband joined one month after the war broke out (no compulsion for him!) and has been out at the Dardanelles, and got invalided home with enteric fever, and has to go out again.

As for the so-called Married Men's League asking Lord Derby to resign, shame on them after the valuable work he has done! I suppose if the Germans got here the shirkers would want the Tommies brought home from the different battlefields to protect them. As for conscientious objectors, well, they ought to be shot as traitors; none who are loyal to their country would refuse point blank to defend it.

A Disgusted Soldier's Wife with Four Children, 28 March 1916,

Chester Chronicle, 1 April 1916

Nationally, of the small percentage of the men appearing before Military Service Tribunals, around 2 per cent, appealed against conscription as conscientious objectors, totalling around 16,500 men who refused to fight. Most were pacifists, and approximately 7,000 were granted non-combatant duties such as cooks, medical orderlies, or stretcher bearers on the front line. Some of these tasks, especially the latter, carried extreme risks and had a high casualty rate. Many were exempted on religious grounds, especially Jehovah's Witnesses or Quakers, who were prominent in this group. A further 3,000 were detailed to special work camps or farms where there was work of 'national importance', while 6,000 were imprisoned after being forced into the army and refusing to carry out orders. Over 1,500 men refused all compulsory service and refused to carry out any military orders. Such men became known as 'Absolutists', yet were often still drafted into military units. Forty-one were posted to France, and as they were now effectively on active service, if they refused to carry out an officer's order, they were court martialled and could be given a death sentence, although in practice none were executed under direct orders to Haig from the Prime Minister Asquith. The men were returned to England to serve out their prison sentence, although they were released in 1919.

Men sent to detention camps were often subjected to appallingly harsh treatment in blatant defiance of the official orders. Many of those in charge of prisoners were sadistic and appeared to take gratification in meting out violence and torture, often breathtaking in its cruelty. The imprisoned men were reviled by these senior men as cowards, and were abused, beaten up, shackled and even thrown into dungeons.

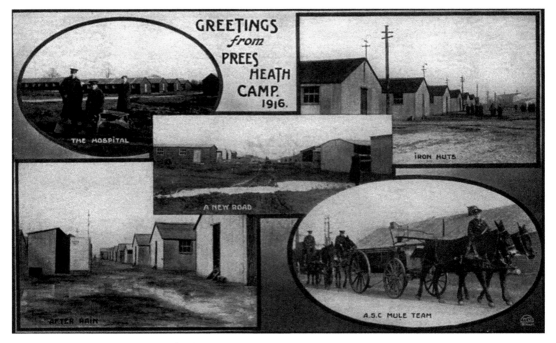

Prees Heath Army Camp near Whitchurch.

In Kinmel Camp, Rhyl (on land adjacent to Bodelwyddan Castle), a group of around twenty men made a protest of non-cooperation and refused to obey military orders. Some had refused to wear khaki, or to shave, and all had refused to drill. One man sat for a lengthy period in his pyjamas when his clothes were taken away, and was placed under arrest still in that condition. As a consequence, they were court martialled and in several cases the sentence was two years' hard labour in military prisons.

Treatment meted out in Prees Heath Camp just south of Whitchurch was even raised in the House of Commons. The case concerned an allegation of brutality by a lance-corporal upon a number of conscientious objectors. The Under-Secretary of War read a report made by the General Officer Commanding-in-Chief, of Western Command (based in Chester). The replies by listening Members of Parliament clearly reflected the attitude toward objectors:

On June 19 1916, a telegram was received from Mr Bland, 203 Barkerhouse Road, Nelson, to the effect that certain conscientious objectors in the 17th Battalion Cheshire Regiment at Prees Heath Camp were being ill-treated by a Lance-Corporal Barker. A copy of the telegram was at once sent to the General Officer Commanding Prees Heath Camp for full inquiry and report. The report has now been received and is as follows:

'Private Carradice arrived in camp under escort, and was placed in the guard room. He stated that as a conscientious objector he could obey no orders. The next day he was sent to his own tent, and when ordered to turn out on parade would not do so.

Lance-Corporal Barker then seized him by the back of the neck (*hear, hear*) – and ejected him (*hear, hear*). As he would not march anywhere, Lance-Corporal Barker cuffed him along (*hear, hear*). Private Carradice was next taken to the bath cubicle, and refusing to wash, was handed somewhat roughly by Lance-Corporal Barker having his ear pulled (*hear, hear*).

The case of Private Ingham is practically similar. The Commanding Officer states that these men (with five others) were seen by him on arrival. They refused to answer any questions, were most disrespectful in manner, and stated they were conscientious objectors. He consequently directed that they should be handed over to a non-commissioned officer who was a good disciplinarian (*hear, hear, and laughter*). On visiting the tent where the man was placed, he found it in a dirty and disgraceful state ('*Oh*'). The men absolutely refused to clean up ('*Shame*'). He then directed Lance-Corporal Barker to have the tent cleaned, and – as is done with all recruits – to see that they had a bath (*hear, hear and laughter*). He (the Commanding Officer) states that he has never seen any violence offered to these men, nor have they made any complaint to him.'

It is undeniable that undue force was used by Lance-Corporal Barker (*hear, hear, and cries of* 'No', and Mr G.D. Faber (U-Clapham): '*Not at all. Every schoolboy has to put up with it*'). He was carried away by excessive zeal (*hear, hear, and renewed cries of* 'No') – in his efforts to carry out the instructions of his superior officer. No permanent injury was inflicted however, and what roughness he used was under great provocation ('*He did his duty*') as the men appeared to have been in league to dispute all orders given to them. As Lance-Corporal Barker has crippled fingers, it would be physically impossible for him to have struck severe blows. It may be added that disciplinary action has been ordered to be taken against Lance-Corporal Barker for his treatment against these men ('*Oh*') – and that he is not in future to be placed in charge of conscientious objectors ('oh','*Shame*' and cheers). Mr Bland has been written to, informing him that disciplinary action has been taken in this case. Orders have been given that in future no attempt is to be made to compel soldiers physically to obey orders, but that if insubordinate they are to be forthwith remanded for trial by district court-martial. (*Hear, hear, and Mr Faber:* '*Shame*').

Chester Chronicle, 8 July 1916

Thought to be the first conscientious objector brought before a tribunal was a young man originally from Chester. His parents were married at Neston Parish Church in 1893, his father Llewellyn hailing from Gwernafield, Flintshire, and his mother from Ness. Soon afterwards they settled in Chester in No. 19 Bouverie Street. Llewellyn Robert was a life assurance agent and after promotion to assistant superintendent for the Prudential Life Assurance Company, the family had moved to No. 388 Stockport Road, Bredbury. By 1911, fifteen-year-old Walter was employed by the Calico Printers Association, learning his trade as a junior architect's draughtsman.

However, when the war came, he began to follow the pacifist cause and by the time of the 1916 conscription he was already politically active in opposing the war.

Fenner Brockway, the British pacifist and CO, who spent part of his wartime jail term in the dungeon of Chester Castle, recalled their first encounter,

I first met Walter Roberts on the eve of the hearing of his claim for exemption by the Local Tribunal at Bredbury. I was so attracted by his quiet strength and transparent sincerity that I decided to put off another engagement in order that I might be present at the proceedings. I believe Roberts was the first conscientious objector to appear before a tribunal. In all our subsequent struggles he has typified to me the cause for which we have been witnessing. The members of the Tribunal were aged and experienced men. Roberts looked younger than his twenty years. 'Are you not very youthful to hold such decided opinions?' the Chairman asked. 'I have been taught from my mother's knee that to hate and to kill is contrary to the teaching of Christ,' he answered with frank simplicity.

His case went to appeal, held at Macclesfield Town Hall. His father spoke passionately of the Christian upbringing he had given his boy: 'I and his mother are responsible for the views he holds,' he pleaded. 'We have taught him to love his enemies and to be kind to all men.'

It took just three more minutes before he was dismissed. Four days later he heard that all exemption had been denied him.

He continued his refusal to recognise the decision of the tribunal and while awaiting arrest, Roberts dedicated himself, with untiring devotion, to the work of pacifist propaganda. He distributed leaflets day after day, and night after night, on behalf of the ILP and the NCF. 'I must make the best of every hour of liberty I have left,' he told Fenner Brockway.

On Tuesday, May 16th, I was travelling from Manchester to London to answer the summons at the Mansion House in connection with the prosecution of the members of the National Committee. As the train pulled into Stockport Station, I heard the strains of the *Red Flag* being sung and cheers being raised. On the platform was a group of absentees, including Roberts, under the charge of an escort of soldiers. We made room for them in our carriage, and they travelled with us as far as Crewe.

Although Roberts was the youngest of the group, the others instinctively looked to him as leader. He was full of words of cheer, particularly for one lad who had become a little overwrought by the Police Court proceedings. I remember him sharing his lunch with one of the soldiers under whose care he was. His last words to me were, 'I'll try to act worthily of our cause.'

In the carriage was an obviously prosperous business man. 'What a nice young fellow,' he remarked about Roberts when we had said goodbye to him and his comrades. 'It's a shame that lads who think it wrong to fight should be treated like this.' Afterwards I learned that my fellow-traveller was a munitions manufacturer on his way to London to interview Mr. Lloyd George. 'If I get the chance,' he said, 'I will tell him what I think about all this.'

[Brockway founded the No-Conscription Fellowship, he served time in prison for his pacifist activities, and later became a Labour MP. He co-founded War on Want and entered the Lords as Baron Brockway in 1964 from where he continued to campaign for disarmament and world peace. His statue stands in Red Lion Square, London. He said of his own experience during the war,

I was to be taken to Chester Castle and my wife travelled to Chester with me. The Cheshire Regiment did not have a good reputation for its treatment of objectors. The previous week the newspaper had carried reports of how George Beardsworth and Charles Dukes, both subsequently prominent trade union leaders, had been forcibly taken to the drilling ground and kicked, punched, knocked down and thrown over railings until they lay exhausted, bruised and bleeding. I was a little apprehensive.]

By now, Roberts had been handed over to the army, but after refusing to obey orders, he was sent to Wormwood Scrubs, and from there to Bedford to serve a sentence of four months hard labour. He had nearly concluded his sentence when he was removed to Dyce.

Opened in late 1916, Dyce Camp near Aberdeen was set up as a Home Office scheme, as an alternative to mainstream prison where treatment by staff and inmates was usually harsh. It also avoided the problem of using commercial employers who were reluctant to have 'conchies' foisted upon them by the authorities. Housing 250 conscientious objectors, they were to break rocks in a local quarry for road building and be paid 8d per day (worth around £2 today). Living conditions at the camp were very basic and many of the men were unused to hard labour. The first job for the men was to erect twenty-seven bell tents and three marquees because

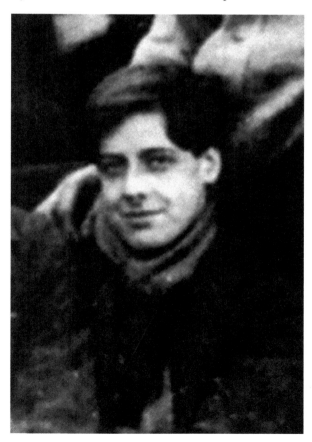

Walter Roberts from Chester, a pioneer in the peace movement, who died at Dyce Camp.

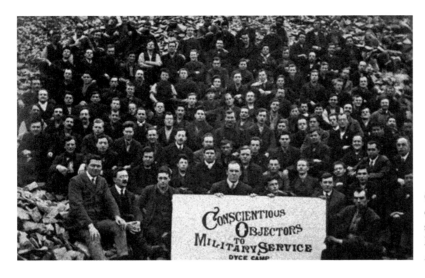

Conscientious objectors in the stone quarry at Dyce Camp near Aberdeen, 1916.

there was no living accommodation on site. The men were housed in these tents that had been disposed of after the Boer War by the army as inadequate. Branded as degenerates by the local press on their arrival, those sent there came from all walks of life: teachers, academics, shopkeepers and labourers. They were in the main well educated and articulate – and even set up their own camp newspaper, *The Granite Echo*.

Twenty-year-old Walter Roberts arrived at Dyce after four months' hard labour in prison and like most of the workers, he developed a cold when he arrived at the camp. On Wednesday 6 September he dictated a letter to his mother:

> As I anticipated, it has only been a question of time for the camp conditions here to get the better of me. Bartle Wild is now writing to my dictation, as I am too weak to handle a pen myself. I don't want you to worry yourself because the doctor says I have only got a severe chill, but it has reduced me very much. All these fellows here are exceedingly kind and are looking after me like bricks, so there is no reason why I should not be strong in a day or two, when I will write more personally and more fully.

Two days later he was dead. The village doctor had diagnosed a chill, but the following night Roberts fell from his bed and ended up lying on wet ground for two hours. The next day the doctor said he was too ill to be moved, but no nursing or medical attention was provided – one of Roberts' colleagues (a dentist) did what he could to help. By early Friday Roberts had died of pneumonia before any medical help could be requested.

Fenner Brockway wrote to the government demanding an inquiry. Men in the camp who had formed a representative committee stepped up a letter writing campaign complaining about the conditions. There were visits to the camp by Home Office officials and by future Labour Prime Minister Ramsay McDonald.

On 19 October, following a debate in Parliament, it was announced that Dyce Camp would close, and was shut down six days later. Barely two months after

their arrival the conscientious objectors were dispersed to prisons across Britain to complete their sentences.

Fenner Brockway reported the words of Walter's brother:

'To all of us his life and death must be an inspiration. Walter's death has strengthened me in my determination to continue, if need be, the glorious fight in which he has laid down his life,' writes his younger brother. 'It has also made me feel that we should love more and more and more. Although I miss my brother to an extent which I am incapable of explaining, yet I am proud to have had such a brother, and that he should have died fighting for our Cause.' To everyone who knew Walter Roberts his death will bring similar determination. He was worthy to be the first to die in our struggle.

Walter Leslie Roberts was brought home and buried in St. Deniol's churchyard in Hawarden on the 13 September 1916. The inscription on his grave read:

> The young hands have carried His standard
> Right on to the end of the day
> And we know that the nations will follow
> Where thou hast trod the way.

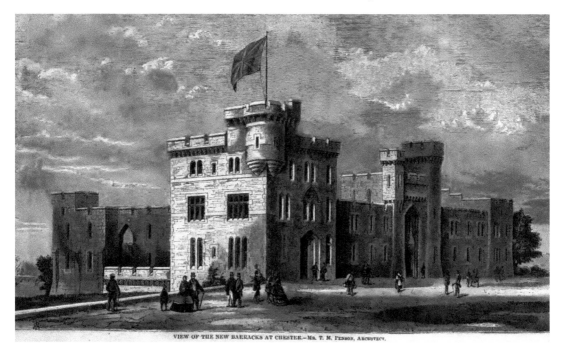

VIEW OF THE NEW BARRACKS AT CHESTER.—Mr. T. M. Penson, Architect.

Chester Militia Barracks, built by 1861 on Castle Esplanade and in use by the Cheshire Regiment during both wars. Demolished in 1964 and replaced by the County Police Headquarters, completed 1967. This in turn was demolished in October 2006 to be replaced by the HQ Cheshire West and Chester Council office complex.

Chapter 4

Prisoners of War

Although many studies have been made of the experiences of prisoners of war during the First World War, popular awareness is greater of prisoners and their stories in the Second World War, especially when recalling accounts of *The Great Escape*, *Stalag Luft III* and *Colditz*. Yet a staggering total of almost 8 million men were held captive during the First World War. Allied prisoners totalled around 1.4 million (not including Russia, which lost 2.5–3.5 million men as prisoners.) of which 192,000 were British and Commonwealth. Approximately 3.3 million men from the Central Powers became prisoners. Behind the lines, Germany held 2.5 million prisoners; Russia held 2.9 million; while Britain and France held around 720,000, and even the U.S. held 48,000. Warring nations were expected to abide by the Hague Convention on the fair treatment of prisoners of war, and their rate of survival was generally much higher than men at the front. Individual surrenders were uncommon and large units usually surrendered en masse (an extreme example being the Battle of Tannenberg where 92,000 Russians surrendered). In the camps, conditions varied, but thanks in part to the efforts of the International Committee of the Red Cross (ICRC) and inspections by neutral nations, some were more tolerable, although conditions in Russia remained terrible. Nevertheless, in Germany food was very scarce and starvation was common for prisoners and civilians alike, causing death for approximately 5 per cent of the prisoners.

The ICRC set up its International Prisoner of War Agency in Geneva in October 1914 with the task of centralising information about POWs and the despatch of gifts from home. Lists of prisoners sent to Geneva by warring nations enabled the compilation of index cards and files for each prisoner. The cards were organised by nationality, and also added to individual files were regimental information and grave sites of those that had died. Almost 5 million index cards were created and 1,854,914 parcels and consignments of collective relief dispatched. Occasionally, the Red Cross arranged for men to be repatriated during the war. This was usually because the men were very ill and needed hospital treatment at home. In many

cases illness was terminal. Prisoners in such situations were exchanged for German servicemen held in Britain, so there was often a delay in organising inspection boards and other bureaucracy before the exchange could be confirmed. On their arrival back in the UK, the men were debriefed by the authorities to glean information as to their treatment and other useful detail regarding activity behind the lines.

There were various experiences endured by prisoners. Not all were well treated, which is understandable and expected in warfare, despite the agreed conventions in place. Many were put to work behind the lines, usually in industrial work, such as mining, or working on farmland. Universally, their German captors came in for most criticism regarding the quality of the food. The local press at home was clearly vehement in its reportage, and an objective eye is often needed to search for balance. The prisoners were almost always malnourished, but it must be remembered that Germany was suffering regarding the scarcity of food and foreign prisoners were always going to be last on the list of priorities in the distribution of essential supplies. Many prisoners revealed that they would not have seen the war through had it not been for the supply parcels sent from home.

This is testament to the efforts of the Red Cross and the various fundraising organisation that persevered throughout the war to keep men behind the German lines supplied and buoyed with packages of food and clothing. In many cases this would be the only new clothing they would receive to replace the clothes they were standing up in when they were captured.

Towns and villages began to set up Comforts Funds to help alleviate the strains the fighting men abroad were living under, by providing foodstuffs, clothing and other necessities. A variety of activities were organised to encourage contributions, while funding and collections also went towards the Red Cross parcels now being despatched to the prisoner of war camps.

Among the first communications received in Chester from British prisoners of war in Germany was that sent to Mrs G. Rogers of No. 71 Philip Street, Hoole, from her husband, Private G. Rogers (7715), Cheshire Regiment. The *Cheshire Observer* of 24 October 1914 reported,

Englischer Kriegsgefangeniusendung,
M.B.10, Munster Lager, Hanover, Germany.
 'You will see by this card that I am still in the land of the living, but I am a prisoner. I shall be released and sent home as soon as peace is declared, so there is no need for you to worry about me, and you might let them all know at home that I am quite safe and well, but hungry. You will be allowed to write, and also to send some foodstuff, so if you can think of something filling that will go in a small space you might send something to eat. Don't send cigarettes or tobacco'.

Private Rogers had served seven years with the Cheshire Regiment in India, returning just over two years previously. He had recently married and had only lived in Chester ten weeks before being called up. Mrs Rogers packed a box of Bovril, chocolate, cocoa, ham and tongue etc., which she sent off to her husband. Cigarettes

at that time were banned by certain camps and anything received would have simply been confiscated by the guards.

Mrs J. Tongue of No. 4 Orchard Street, Chester, whose husband was called up with the Cheshire Reserves at the outbreak of war, also received a card:

> I take great pleasure in writing these few lines hoping you are in the best of health, as it leaves me at present. I am a prisoner of war, and not allowed to tell you anything concerning the War, but you can let me know all family affairs. Please remember me to all at home, and give my best love to the children, hoping they are well and hearty. Try and send a cake.

The appeals for support for the Soldier' Comforts Funds and the Cheshire Regiment Prisoner of War Fund continued throughout war. Various initiatives were introduced to encourage donations and fundraising schemes, while regular feedback was given in the local pages of the press.

By mid-1918, numbers of known prisoners on the books of the organisation was almost 500. Each man was sent three parcels of food every fortnight, each parcel costing 8s. The pressure on voluntary contributions was immense. Of course, parcels to prisoners of war did not always reach their intended destination, most especially as Germany was going through a desperate food shortage by the last months of the war, and a sceptical public often affected available finances. Any correspondence from recipients was frequently published to reassure the public of the worth of their contributions. A typical publicity drive would be thus:

Postcard from Munster Lager Prisoner of War Camp.

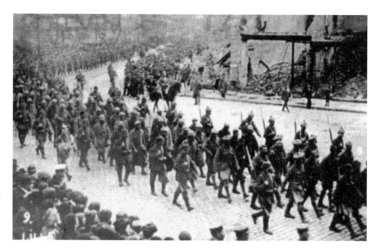

German infantry escorts a long column of British and French prisoners, with Scottish soldiers to the fore, through a shell-damaged town on their way to internment.

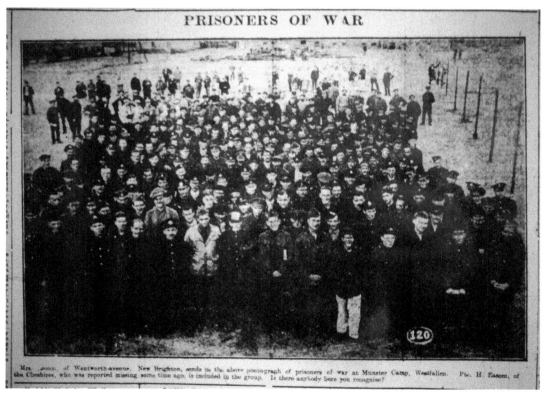

PRISONERS OF WAR

Mrs. ..son, of Wentworth-avenue, New Brighton, sends us the above photograph of prisoners of war at Munster Camp, Westfalien. Pte. H. Easom, of the Cheshires, who was reported missing some time ago, is included in the group. Is there anybody here you recognise?

Prisoners of war at Munster Lager, including men of the Cheshires.

The delight of the men receiving the grocery and clothing parcels has been pathetically expressed in many letters received from the prisoners of war, and we feel that those who can afford to send donations to the Mayoress' Fund will do their utmost to mitigate the conditions of the men who are suffering the pangs of hunger through no fault of their own. In connection with the fund, the Mayoress and a committee of ladies are organising a sale of goods by auction to be held at the Town Hall, on November 5th and 6th, and

donations are requested for this special object, the proceeds of which will be credited to the Cheshire Regiment Prisoners' of War Fund.

Cheshire Observer, 21 September 1918

Here is a typical letter sent to Miss Brown, in this case from a battalion major at the front. The sense that the men had not been forgotten by those at home must have been comforting.

6 June 1918
Dear Miss Brown,

The cases of tinned food, cigarettes, and tobacco arrived on the 1st of June and could not have come at a better time for their arrival as the whole battalion has been out on operations, and had only just returned to our summer camp. We had been unable to get any small comforts for the men for some time – so that the kindly gifts were very welcome and doubly appreciated. It may be as difficult for you to realise as it is more me to express our gratitude for your kindness and remembrance. Being so far away, one is apt to feel forgotten, therefore gifts from home are immensely appreciated.

Yours sincerely Major D. James

Miss Brown, the co-ordinator for the St Mary's Hill Association fundraising charity, was quick to add a request for donations for more items 'such as socks, shirts,

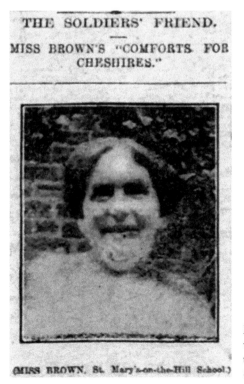

THE SOLDIERS' FRIEND.

MISS BROWN'S "COMFORTS FOR CHESHIRES."

MISS BROWN. St. Mary's-on-the-Hill School.

Miss Brown of St Marys-on-the-Hill School, who worked tirelessly on the sending of parcels to soldiers at the front and in POW camps. (*Chester Chronicle*, 11 September 1915)

mufflers etc' with a deadline for August as they were intending to get them out there for Christmas. Some of the men may have been home by then to receive gifts in person.

As men were released through the exchange programme, they were quick to thank those at home in full, now that they were free to write at length:

A 'CHESHIRE' IN SWITZERLAND
GRATITUDE TO THE MAYORESS'S FUND

The Mayoress of Chester (Mrs Frost) has received the following interesting letter from Private C. W. R. Noyes, Cheshire Regiment: - 'To the Mayoress and all who are working on behalf of the prisoners in Germany. I wish to thank you one and all for your kindness to me during my internment in Germany. I cannot find words strong enough to express my gratitude to you all. As you can see, I am now in Switzerland, and I hope now to regain my health and strength. I shall not need any more food parcels from England, as the food here is good and plentiful. We received a splendid reception from the Swiss and English people. We were actually buried in flowers, cigarettes etc. How lovely it is to be back in civilisation once more! I think I deserve a good time after spending two years behind barbed wire and nearly starved. The boys in Germany need all the parcels that can be sent to them, as it is the food from England that keeps them alive. The weather here is lovely and the scenery beautiful. I must now conclude, once more thanking you for your kindness and wishing your fund every success.'

Chester Chronicle, 2 September 1916

[Private Noyes had been in France since 16 August 1914, and was one of those captured at Mons the following week.]

When several prisoners of war were released in March 1918, there was great interest in the stories they had to tell. Clearly there was the issue of censorship and exaggeration, but as more men began to tell their stories a similar picture began to emerge. Sergeant W. A. Lloyd began to write home as soon as he was able, from where he was recuperating in Holland. Sergeant Lloyd was part of the 1st Battalion, Cheshire Regiment, that was captured at Mons in August 1914 and had spent three years and four months in POW camps. His letters were sent to Miss Brown, the first of which was published in the *Cheshire Observer* on 8 June 1918. He began,

On account of its being forbidden by the German authorities to keep a diary during the time that I was a guest of the Huns, you must excuse me if I omit dates and places as I have to recount all that I write from memory. Everyone should now be acquainted with what happened on the 24th August 1914, so I think there is no necessity for its reproduction here.

Such news may have been fresh in the minds of Cheshire folk reading his letters, but a century or more on, it is worth mentioning again those early events of the first month. The 1st Battalion of the Cheshire Regiment were in the thick of the action from the early stages of the war. Landing at Le Harve, they were swiftly moved up to the front line and became part of the first major British Expeditionary Force

military engagement on the morning of 23 August at Mons, where it soon became a retreat against an overwhelming force. The German 1st Army attacked British positions, and a series of bridges over the canal saw the heaviest fighting as the outnumbered British tried desperately to stop them crossing. By late afternoon, the British were forced to retreat – having suffered some 1,600 casualties, around half of whom were taken prisoner. German casualties are estimated to have been around 5,000 killed, missing or wounded. The Cheshires were initially holding a defensive line, but the following morning it was decided to send them into action to hold up the enemy advance, while the remainder of 5th Division withdrew. Deployed along the road between the villages of Audregnies and Elouges, some 12 miles south of Mons, there was no time to dig protective trenches and the troops had to find what cover they could. There were considerable gaps between the companies and communication was difficult. By midday, the sound of enemy gunfire could be heard. The British forces were soon overwhelmed and after heavy losses began to withdraw. By 6.30 p.m., it was realised that further resistance was impossible and the order to cease fire and surrender was given. The 1st Battalion had engaged four German regiments for most of the day allowing the 5th Division to complete its withdrawal. The cost had been high. Of the twenty-seven officers and 934 other ranks present in the morning, only seven officers and 200 other ranks remained. Overall, more than 600 men were taken prisoner.

Sergeant Lloyd continued,

Firstly, I must give you an account of our journey to Germany. On the night of the 24th, after being collected by the Huns, we bivouacked on part of the ground where the action took place, surrounded by sentries. We were permitted to collect the dead and wounded from within a certain radius, and having in my possession the identity discs of the men whom we buried the following morning, I am, therefore, able to give a list of their names, which are as follows; No.7402 Private J. Wilkinson, 8720 Private J. Unsworth, 9060 Private W. Byrne, 7451 Private J. Jones and 6879 Private J. Arnott. Captain E. R. Jones and Lieutenant Campbell were buried during the evening of the 24th. 10083 Private E H Nolan, who was severely wounded in the stomach, I hear, has since died.

[NB. The officers were recovered, identified and buried elsewhere; Captain E. R. Jones in Wiheries Communal Cemetery, near Mons, Belgium, and Lieutenant Campbell in Cement House Cemetery in Langemark north of Ypres (Ieper). Although the rest of the men were also buried, and this being reported by Sergeant Lloyd, the fact that the dog tags were removed meant that if the graves were found they were not identified. Consequently, they all appear on La Ferté-sous-Jouarre Memorial in France, which commemorates some 3,740 British servicemen who died serving with the BEF in August, September and early October 1914, who have no known grave.]

After the harrowing experience of battle, being taken prisoner, and burying colleagues where they lay, Sergeant Lloyd and his companion were soon on the move:

On the morning of 25th we were marched under escort to a village three kilometres from where we bivouacked the previous night. On arrival in the village we were billeted in a church, where we met a good many more NCO's and men of the Regiment. During our stay in the church, we were searched and deprived of knives, cap badges and titles, etc. Money and watches were even taken from some of the NCOs and men. On the morning of the 26th we marched out of the village about 650 strong, all arms of the service including officers, en route for Germany. That night we were billeted in St George's Convent being well looked after by the Sisters of Mercy.

Early on the morning of the 27th found us once more on the trek. We billeted in the evening in a public school, receiving food from the inhabitants of the town. We were once more on the move at 8 a.m. on 28th which turned out to be our last march before entraining for Germany. We arrived at Halle (Belgium) about 18.30 the same day, and were placed in the cellar of a brewery (minus beer). In the afternoon we were marched to the railway station at which place we entrained at about 4pm. Our mode of conveyance being coal trucks, which were in a very filthy condition. Previous to entraining, the German officer in charge apologised for not being able to procure better accommodation for us (German *Kultur!*).

During the night of the 28th, large fires were observed, which lit up the surrounding country. As we drew nearer to the fires, we found out that the city of Louvain was in flames. On account of travelling at a slow rate, I was able to discern the following: The buildings of the city on the left side of the railway had been burnt to the ground. The part of the city on the right of the railway, which I presume contained those historical buildings which were well known throughout the world, were burning fiercely. How the inhabitants fared during this great fire I have not yet been able to ascertain. We arrived at Liege at about 4 p.m. on the 29th and stopped for about half an hour. During our stay, a good many of the inhabitants collected round the station carrying baskets of food which the Germans would not allow them to distribute among us.

During the forenoon of the 30th, we arrived at Cologne amidst hails of stones and curses. Even the children spat at us. Some of the boys asked for coffee and the reply was 'Water is good enough for the Englander'. Of course, some could not let this reply go unanswered and they replied in turn, 'Lions drink water'. We asked for bread and received stones. Our stop at Cologne, which lasted for one hour and a half, was due to the changing of our escort, which was not for the better. On the morning of the 31st, between 4 and 5 a.m., we halted outside a town, the name of which I can only remember ended in 'dorf'. We were ordered alight, and marched to a shed, where we were supplied with a gill of coffee, two pieces of bread and two sausages. This was our first meal since we entrained on the 28th at Halle. We were hardly given time to partake of the frugal meal before we were rushed back to the coal trucks, the escort using the butts of their rifles freely. When everyone was within the abode of love (the coal trucks to wit), we again proceeded on our journey, arriving at Munster (Hanover) at 12.30 p.m. on Sunday the 31st August 1914, which turned out to be our destination. Our new escort marched on the station doing the goose-step. The attitude of our new escort towards us made everyone come to the conclusion that we were in for a very rough time.

In my next letter I will deal with the general conditions and treatment and my journey to Soltan.

Cheshire Observer, 8 June 1918

Above left: The regimental colours of 1st Battalion, Cheshire Regiment, hidden after bearers were taken as prisoners of war and safely recovered at the end of the war.

Above right: Drummer Baker, who defied the Germans by hiding the regimental colours following the disastrous Battle of Mons.

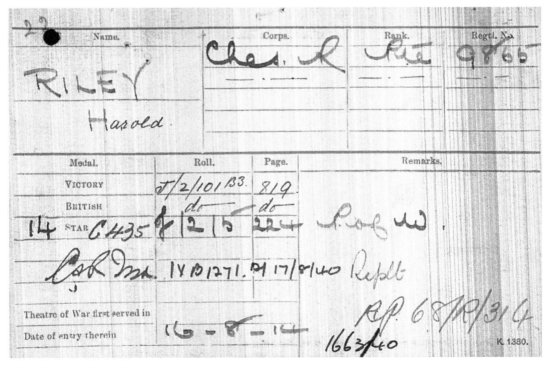

Medal card of Private Harold Riley of the 1st Battalion, who was also taken prisoner ('POW' has been marked on his card) but not before ensuring the colours would be safely hidden.

Cement House Cemetery, north of Ypres (Ieper), the resting place of Lieutenant C. A. Campbell, 1st Battalion, Cheshire Regiment, who was killed in action on 24 August 1914 age twenty-three in the Battle of Mons.

La Ferté-sous-Jouarre Memorial in France, which records the names of the missing men of the 1st Battalion, Cheshire Regiment, who were buried on the battlefield by Sergeant W. A. Lloyd and his fellow captives.

The second letter, published in the *Cheshire Observer* on 6 July 1918:

In my following letters, readers will probably be under the impression that I am over-estimating facts, but not so. I shall have to under-estimate if anything because I shall probably not be able to find words sufficiently strong to place the actual facts clearly before them. My last letter ended with our arrival at Munster (Hanover). It is a small village about 18 kilometres south-east of Soltan, and has a very small population. It is, at the present time, a large training centre for German troops. On arrival, there we were formed up in fours along the road leading to the village surrounded by a ferocious escort, who used the butt of their rifles and

fists very freely on the NCOs and men nearest to them. We were marched through the village, receiving sneers and insults from the poor, ignorant population. During our march along the road, we passed a good many huts, which previous to the war had been used as cavalry stables but which were then being used for the accommodation of between fifteen and twenty thousand Belgian prisoners of war, who were captured at Liege and Namur. Of course, they turned out in force to see Les Prisoneers Anglais, but they soon went back into their abode (of course) when the sentries charged them with fixed bayonets. We also passed the German stone barracks, which I will speak about later, as they eventually turned out to be our quarters. We finally reached the place that had been allotted to us, which turned out to be a large wooded structure, its military term being a riding school. Anyone that is acquainted with the accommodation that a riding school affords for 650 men can picture what we had to endure for five days and five nights. It brought back forcibly to my mind what I had read about the

BLACK HOLE OF CALCUTTA

during the Indian Mutiny. We were formed up in two ranks and searched – pipes, tobacco and cigarettes being taken from us on this occasion. We were forbidden to smoke, forbidden to whistle etc, in fact, I thought we were going to be forbidden to breathe. After having the word 'verboten' fairly hammered into our brains, we were allowed to enter our future abode; the floor of which was from three to four inches thick in loose sandy soil and horse dung. Five minutes after entering we could not distinguish one another through the clouds of dust. It was so bad I thought I was going to be suffocated. We were afterwards marched to the kitchen for the mid-day 'soup' or dirty potato water, one bowl of which was given between five men. Not being provided with utensils to dispose of it, we had to use what nature had provided us with. That was the only meal we received that day. We returned to our abode as hungry as when we had left it. We were locked in at 8 p.m. We were not provided with bedding of any description, so we had to lie down on the filthy floor and make the best of it. Of course, some were more fortunate than others being in possession of a great coat. On the morning of the 1st September, we were early astir, not having been able to procure more than three hours sleep on account of the uncomfortable conditions and a very sharp frost which set in during the night. We received a bowl of hot coffee about 6 a.m. which I can assure you was very welcome. About 9.30 a.m. we received a ration of dry black bread, which constituted our morning and evening meal. Shower baths having been temporarily erected, we indulged in a bath about 11.30 p.m., two dozen towels being provided for 650 men. Those who were fortunate to bath first had the luxury of a dry towel. If the sentry thought we were not quick enough in entering the bath, he helped us in

WITH THE BUTT OF HIS RIFLE

and when he thought we had been in long enough, he helped us out by the same means. We received our daily issue of potato water about 12.30 p.m. under the same conditions as the previous day. We had to endure the same conditions for five consecutive days and nights. On the 5th November we were transferred to the German stone barracks, which consisted of five buildings, each building only having one storey. There were three rooms and four bunks in each. The bunks being placed at the disposal of the senior NCOs and the remainder of the NCOs and men occupied the rooms. Roughly, 50 NCOs and men were placed in each

room, and I can honestly say they were very much over crowded. Straw was issued to sleep on, and it was kept so long in use that NCOs and men became infested with vermin. No underclothing or soap had been issued to us and having only in our possession what we stood up in, it was impossible to keep ourselves clean.

About the middle of October, the straw was ordered to be taken out of the rooms and burned. The rooms were thoroughly cleaned, and mattresses, clean straw, blankets and underclothing being issued. The underclothing which we given at this particular time we had to pay for after we were transferred to Soltau. The German authorities did not give us the option of refusing to pay for it: they stopped the money out of what was sent to us from England. I wonder if the German prisoners in England had to pay for underclothing issued to them by the British Government. It was about this time we were given permission to smoke outside the barrack rooms, the order being received with cheers. Early in October, about 20 British civilians arrived at Munster for internment. They had not been permitted to leave Germany when war was declared. Great credit is due to three of them, who worked with untiring energy on our behalf. They obtained for us better food; in fact, they bettered our conditions all round.

WOUNDED NEGLECTED

For a considerable time after our arrival at Munster the German medical staff refused treatment to the NCOs and men who were wounded, their excuse being that the wounded German prisoners in England were not receiving medical treatment. Early in November, we received our first parcels and correspondence from England, which put new life into us. During the latter part of November, about 5,000 Russian prisoners arrived. I thought we arrived in a very bad condition, but it was nothing in comparison with the condition of the Russians. Some of them could hardly hobble along with the help of sticks. A good many of them were without boots, and they appeared to me not to have seen food for days. I did not see them again at Munster, as they were billeted three kilometres away. On 13th December we had just got things in thorough working order, and things beginning to run smoothly, when we were ordered to move to Soltau, which camp I will deal with in my next letter.

W. A. Lloyd C.Q.M.S.,
1st Cheshire Regiment, House 187, Group II, Schevenimjen, Holland.

In fact, we first heard from Sergeant Lloyd in 1914. By then the authorities, via consuls in Berlin and London, had been advised of the whereabouts of some of the prisoners of war and their contact information, enabling families and the aid associations to get in touch and send them parcels. Prisoners by then were permitted to send postcards home, and they began to arrive regularly. Some were received by Lieutenant Colonel Hammersley of the Cheshire Regiment POW Association, of which this was one:

From Coy. Qr. Master Sergt. W. A. Lloyd, 1st Cheshire Regiment, British Prisoner of War, Barrack 17, I Lager, Soltan, Hanover, Germany. 30th June 1915

Sir, - I write to thank you for the parcel of comforts which we and Coy-Sergt Major Foden received 21st June. On account of our correspondence being limited, it is impossible to acquaint the individual senders and subscribers of parcels of comforts which the NCOs and men of the Regiment continue to receive from different parts of the county.

If something to this effect could be inserted in the local papers of the county, the people concerned would understand. We are all very sorry to hear of the death of Sergt-Major Francis, who was held in high esteem and respect by every NCO and man of the Regiment. Please convey our deepest sympathy to his bereaved family. I can say that every NCO and man of the Regiment is in excellent health, and hoping that our dear ones at home are the same – I sir, yours obediently, W.A. Lloyd.

As the war was drawing to a close, Sergeant W. A. Lloyd wrote again, which appeared in the *Cheshire Observer* on 2 November 1918:

British Worst Treated

The German civilians and soldiers were at this time intoxicated with hatred against the British, which caused a great deal of ill-treatment to the British prisoners of war. The reason of this was – the heads openly declared that England had no reason whatsoever to declare war, but by doing so had prolonged it for an indefinite period. They also declared that the British were nothing more or less than barbarians and the prisoners of war must be treated as such. As there was no one at that particular time appointed to look after the interests of the prisoners, commandants of lagers were given a free hand to deal with them as they saw fit. Commandants gave orders to those under their command, and told them that, if their orders were not carried out, their punishment would be to a speedy despatch to the Front. Needless to say, the poor, ignorant fools carried them out to the letter, and in the majority of cases far exceeded them. The British prisoners were given the hardest and filthiest work that could be found, which consisted of removing the camp refuse, emptying coal trucks at the railway sidings, forest work, the making of canals on the marshes. The latter work was carried out at a place called Cassebrush or better known as Soltun 23008. The men in this lager had to work day in, day out, knee-deep in water, in the most severe weather. They were kept out at work occasionally from 6 a.m. to 9 p.m. without food; this constituted a punishment when the commandant thought that they had not done sufficient work on the previous day. They were very badly fed, and ill-treated to such an extent, that some of them expired through

UTTER STARVATION

Others had to be sent back to their headquarter lagers unfit for further work. In this particular lager one man reported sick at 9 a.m. one Saturday morning. The doctor refused him treatment, handed him over to a sentry, who took him to the marshes to work. The same man was carried back to hospital at 12 noon on the same day dead. Exactly seven days later, another man died in the same circumstances. Both dead through insufficient food and ill treatment. Previous to the burial of these men, the commandant informed the prisoners, that, if they wanted their comrades buried decently, they would have to subscribe a certain amount of money sufficient to pay for the coffins. Failing this they would be buried in a sack. The men, desirous of seeing them decently buried, compiled with the commandant's order.

I saw several of the men of my own regiment who returned to Soltun from the lagers in April 1915, and when they showed me their bodies, I was astonished. They did not have one ounce of flesh on their bones. Readers who have seen photos of the natives during the Indian famine can picture themselves the state of these men. I shall have more to say to say with reference to this lager, as my last nine months in Germany were spent there. Every morning and afternoon the men were paraded outside the commandant's office for work. After the men who paraded had been sent to the work allotted to them, it was always found that more men were required. The men in charge would then send the spare sentries round the lager to collect all the Britishers they could find. One sentry would rush in the barrack with a bayonet fixed and rifle at the charge, while another sentry waited just inside the door of the barracks. As each Britisher appeared, he was met with a swinging butt. I have seen

MEN KNOCKED INSENSIBLE

by this method, and in a good many cases they had to be carried to hospital because the injuries they received were of a very serious nature. I know a case where a man lost his reason through being treated in this manner, and the last I heard of him, he had been sent to a lunatic asylum somewhere in Germany.

Punishments were numerous and various, so I will give you a description of the most severe. For making a complaint of refusing to work, the following punishments were awarded; The prisoner was made to stand on a stool with his back to a tree. He was then tied to the tree from the feet upwards in such a manner, that it was impossible for him to move any part of his body. The stool was afterwards taken away, the prisoner being left in this position for not less than two hours. When he was finally released, he fell to the ground insensible, and in some cases I have seen them kicked unmercifully while in this condition. They were also made to stand rigid facing the sun, wind or rain, under the watchful eye of a sentry with drawn bayonet. If the prisoner moved, the sentry struck with the bayonet on that particular part of the body which he had moved. Some were made to stand to attention, with arms out stretched, width of the shoulders apart, back of the hand upwards, and every time they moved their arms or body they were struck across the knuckles with a bayonet. Cases have been known, after this method of punishment, where men have not been able to use their hands for days and in some cases weeks, and perhaps maimed for life. All these punishments were carried out with a view to breaking the spirits of the Britishers, but, instead, it only made them straighten their backs, compress their lips, and smile when their lot was the hardest, and undergoing the most severe punishment.

WORRIED BY WOLFHOUNDS

At this time, dogs were kept in the lagers. They were of the wolf-hound breed, a very ferocious animal. These dogs were led on a leash around the lager by sentries. When they were let loose among the prisoners, there were some terrible scenes, men's clothing being torn from their bodies and blood oozing from the wounds made by the dog's teeth, where they had entered the flesh. I read myself an account in an English paper, with reference to these dogs, which in my opinion was put in a very mild form, for what reason I cannot say, only probably the person who inserted it did not want to hurt the feelings of the poor

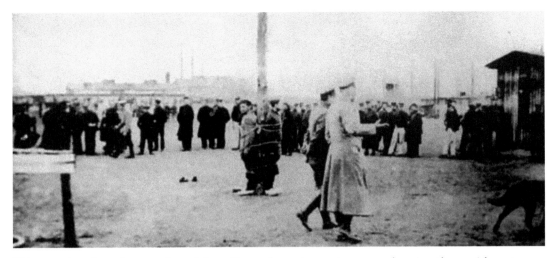

This secretly taken photograph at Soltau Camp shows two prisoners undergoing the punishment described by Sergeant Lloyd. It is not known how this image was taken. However, one POW at another camp later recalled how a Frenchman had frequently carried a crucifix through the camp, in what appeared to be religious zeal. Unbeknown to the German guards, the base of the crucifix held a hidden camera. (Richard van Emden, *Prisoners of the Kaiser*)

> Germans who were permitted to run loose in England at that time. Dear reader, I will now leave you to form your own opinion as to the civilised nature of our lamented 'friends', the Huns.
>
> *Cheshire Observer,* 2 November 1918

The bulk of British prisoners were released soon after the armistice, and by 15 November had reached Calais. A large camp was established at Dover to house 40,000 men, which was later used for demobilisation. By 9 December, 264,000 Allied prisoners had been repatriated, thousands of whom had been released en masse to find their own way back to Allied lines without food or shelter. Many died from exhaustion along the route. When the returning POWs were picked up, they were sent to reception centres on lorries. There they were clothed and fed and despatched by train to the channel ports. At the receiving camp they were then registered into the accommodation before transport to their own homes was arranged. Returning officers were expected to write a report to explain the circumstances of their capture and showing how they had done all they could to evade capture. POWs were given a message from George V – the first ever mass communication from a reigning British monarch – which was in the form of a lithograph written in his own hand:

> The Queen joins me in welcoming you on your release from the miseries and hardships, which you have endured with so much patience and courage. During these many months of trial, the early rescue of our gallant Officers & Men from the cruelties of their captivity has been uppermost in our thoughts. We are thankful that this longed-for day has arrived, & that back in the old Country you will be able once more to enjoy the happiness of a home & to see good days among those who anxiously look for your return. George R.I.

BUCKINGHAM PALACE

1918.

The Queen joins me in welcoming you on your release from the miseries & hardships, which you have endured with so much patience & courage.

During these many months of trial, the early rescue of our gallant Officers & Men from the cruelties of their captivity has been uppermost in our thoughts.

We are thankful that this longed for day has arrived, & that back in the old Country you will be able once more to enjoy the happiness of a home & to see good days among those who anxiously look for your return.

George R. I.

Letter from King George V addressed to returning prisoners of war, 1918.

As prisoners began to drift home, more stories of starvation and cruelty began to emerge. An unnamed Cheshire private, walking with a limp, spoke in London after arriving by train. Taken prisoner eight months earlier, he was employed in Alsace in

stone quarrying and railway building. While engaged on railway work, a German sentry spoke to him in German, apparently giving fresh instructions. The Englishman, unable to understand German, could not obey and the German knocked him down and bayonetted him in the leg. 'The food was awful,' he continued. 'Our day's rations consisted of a loaf of black bread among three of us, with barley water and maize meal tea. One of my pals was shot because he ran into a field to pick up a turnip. When we were released, the Huns left us in a wet wood without food, and we had to walk for about two and a half days before we found the French lines. The villagers were awfully good to us when they had the opportunity, and would always give us any food they could spare if it was at all possible. But they were so terrorised by the German militarism that it was very little they could do for us.' (*Chester Chronicle*, 30 November 1918).

On Thursday an affecting scene was witnessed at Chester Station when several heroes of the Cheshire Regiment arrived from Holland after a period of four years' imprisonment in Germany. The soldiers were welcomed by their relatives and friends and received an ovation from those assembled on the station platform. Among the repatriated men was Corporal T. Tipton, Cheshire Regiment, whose home is at 9 Tower Street Chester. He was captured in 1914 and left Germany among other wounded prisoners last January, having been interned in Holland since that time. We offer these gallant soldiers congratulations on their reunion with their families, and wish them a speedy return to health and strength after the trying time they have experienced during captivity.

Cheshire Observer 26 October 1918

One aspect of the 1st Cheshire's experience at Mons in August 1914 that still rankled was the loss of the battalion flag, last seen on the battlefield on the 24th. Four years later, a letter appeared in the *Chester Chronicle* of 30 November 1918:

On Sunday afternoon I had the honour of going over with the commanding officer to a place near Mons to receive back the battalion flag, which had been lost in 1914. It has quite a history attached to it. The drummer who carried it in the retreat was severely wounded, and afterwards died. He handed it over to another drummer, who was also wounded, but in spite of this, he dashed into a loft and hid it under some corn. On being taken to a Belgian convent to have his wounds dressed, he asked the sister there to get somebody to recover the flag, and put it in a safer place. At the risk of their own lives, the cure and the schoolmaster went and found the flag, and hid it in their trousers. The Huns had heard about the flag, and searched all the houses for five days. The cure kept it first in his house – then behind the choir stalls in the church – then handed it over to the maire, who had kept it ever since. We saw them all, the cure, the sister of the hospital, and the schoolmaster. Quite an interesting experience.

(Adjutant of the 1st Battalion, Cheshire Regiment)

The flag was an exact miniature of the Cheshire's regimental standard, and had been sewn by wives of the 1st Battalion's officers in 1911 as a company shooting trophy. In August 1914, it was taken to France by B Company, and the drummer it was entrusted to, following the wounding of the original keeper, was 9461 Charles Baker.

Cut off and fearing capture, it was he who hid it in the roof of a house in the village of Audregnies near Mons, concealing it under straw. Baker passed the information to his friend, Private 9865 Harold Riley, who confided the secret to a nun, Sister St Loudon, who was treating his wounds. (Both men were taken prisoner and survived the war.) The nun told the village priest, Father Soudan, who, together with the village schoolmaster, Monsieur Vallee hid it behind choir stalls in the local church. As the Germans intensified their searches, the colour was moved and hidden yet again, this time furled inside a pipe in M. Vallee's school. In November 1918 at the end of the war, a colour party from the 1st Battalion returned to the village to recover the colour from the faithful villagers, and presented the trio (the sister, priest and headmaster) with a silver rose bowl each, in an expression of the battalion's gratitude.

In 2011, the schoolmaster's bowl was spotted in a Belgian antique shop, which was purchased and is now on show in Cheshire Military Museum in Chester Castle. The museum is also the permanent home of the much travelled and recovered battalion colour.

SHOT AT DAWN

Lance Corporal 17790 William Alfred Moon, 11th Battalion, Cheshire Regiment. shot for desertion 21 November 1916.

William Alfred Moon was born in Chester in 1896. His father was a Yorkshire man from Sheffield and his mother, Mary, a local Chester girl, but by the time he'd reached his teens, his parents, who had married in 1879, had split up. His father was living in a lodging house in Cuppin Street, and working as a furniture porter, while William was living with his mother and older sister in No. 22 Commonhall Street, and now bringing in a wage as a stationer's porter at the age of fifteen. By nineteen he had volunteered, no doubt thinking the war would give him a more adventurous life and a better wage, as did many local lads of his age, and was posted to the 11th Battalion, Cheshire Regiment.

After several months training, the battalion landed in France on 26 September 1915. In December 1915, he was injured when an artillery shell landed near him and he was hospitalised at least twice as a result. A few months later he was back in the line and facing the horrors of the first day of the Battle of the Somme on 1 July 1916.

Eventually in October the battalion was pulled out altogether when they moved to Albert on the 22nd, then to Bailleul via Warley, Anthieule and entraining at Doullens on the 29th. Records have not survived, but it seems William had deserted before then, writing later, with some understatement, that the explosion of his mate's head and brains into his face put him 'in a queer state'. Shell shocked, he had had enough, and clearly voted with his feet before he too would lose his mind completely, and his life.

[Prisoners did escape from the German camps. One soldier, Lance Corporal John Southern, had been with the Cheshires at Mons and was taken prisoner in October 1914. He was determined to get out – he was recaptured twice, before

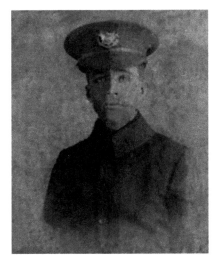

Lance-Corporal 17790 William Alfred Moon,
11th Battalion, Cheshire Regiment, shot for desertion on
21 November 1916.

Medal card of Lance-Corporal Moon, recording 'Shot for desertion'.

succeeding on his third attempt. He made it back to Chester via Holland, where
after a month's rest he signed on again until 1919.]

He was found, brought back to Bailleul, convicted by court martial of desertion
and executed by firing squad ten days later. He was aged just twenty years old.

William is buried in Bailleul Communal Cemetery Extension, Nord, in a
Commonwealth War Grave. It was rare for executed men to appear on war
memorials, but Lance-Corporal William Alfred Moon is on the citizen's memorial
in Chester Town Hall.

Corporal 10459 George Povey, 1st Battalion, Cheshire Regiment shot for quitting his post, 11 February 1915.

George Henry Povey, born in Sealand in 1891, was one of eight children of Dinah and Robert Povey. In 1901 the family lived at No. 2 Davies Cottages, Hawarden, where the family were supported by the wages of Robert and his eldest son Thomas (eighteen), who worked as sheet metal packers. Later they moved to No. 51 Primrose Street, Connah's Quay.

George was an early volunteer when the war came and was posted to the 1st Battalion, Cheshire Regiment. After the disaster of the Battle of the Mons, the battalion had reformed and were holding the line near Wulverghem in the Ypres Salient during December and January 1915. After a brief lull over the Christmas period, hostilities resumed, and sometime during this action Corporal Povey quitted his post. A number of soldiers had done this before and had been separately tried and sentenced to death by courts martial, but thus far their punishments had been commuted to lesser, mostly custodial sentences. Quite why Povey was executed for a similar offence is unknown: his case may have been more serious, or he was now being made an example of to prevent further occurrences.

On 8 February, with no reprieve forthcoming, Corporal Povey was executed at St Jans Cappel in the Ypres Salient at 7.45 a.m. on 11 February 1915 aged twenty-three. Any record of his burial did not survive and he is recorded as having no known grave. His name is engraved on the Menin Gate Memorial to the Missing, Ypres, Belgium.

Both men were officially pardoned along with 304 soldiers of the British Empire executed for certain offences during the First World War under the mass posthumous pardon enacted in section 359 of the Armed Forces Act 2006, which came into effect by royal assent on 8 November 2006.

Shot at Dawn Memorial, National Memorial Arboretum near Alrewas, Staffordshire.

Chapter 5

Victoria Cross Heroes

Private Thomas Alfred Jones VC, DCM, 1st Battalion, The Cheshire Regiment

On 26 October 1916, the War Office announced in the pages of the *London Gazette*, 'His Majesty the King has been graciously pleased to award the Victoria Cross to No. 11000 Private Thomas Alfred Jones, Cheshire Regiment. For most conspicuous bravery.'

This was the first VC of the Cheshire Regiment and came as a result of one of the most remarkable actions of an individual soldier during the entire war.

Private Thomas Alfred Jones, or 'Todger' as he was known, came from Runcorn. One of nine children, he was born on Christmas Day 1880 at No. 39 Princess Street, to parents Edward and Elizabeth. Edward was a fitter at the Hazlehurst Soap Works, Runcorn, where he worked for sixty-two years, and was also a Methodist preacher at the Ellesmere Street Free Church in the town. He married Elizabeth Lawson on 18 April 1868 at Frodsham Parish Church. Young Thomas was educated at Runcorn National School, before becoming an apprentice fitter at the same firm as his father. Once he'd served his time, he moved on to work as an engineering fitter on the vacuum plant at the Salt Union Works at Weston Point, Runcorn.

Aged twenty, he enlisted with a company of the 2nd (Earl of Chester's) Volunteer Battalion on 15 January 1900, which became the 5th (Earl of Chester's) Battalion, Cheshire Regiment, when the Territorial Force was formed on 24 April 1908. He built quite a reputation for his marksmanship and was awarded the Territorial Force Efficiency Medal in 1912. He resigned from the Territorials the following year, and went on to the National Reserve.

On the outbreak of war he was recalled, and hoped to enlist in the Royal Engineers when he attested in Runcorn on 31 August 1914, but this was turned down and he remained with the 5th Battalion, Cheshire Regiment. After several

months in training camps, the battalion arrived in France on 16 January 1915, but not before he overstayed his home leave by four days, and was punished on his return on Christmas Eve 1914, forfeiting four days' pay.

On 25 September 1916 while still on the Somme, the Cheshire's were digging in, making their position secure after taking the village of Morval. Coming under intense sniper fire, Jones acted on his own initiative, climbing out of the trench and heading to the German lines. Almost immediately he was hit by a sniper hiding in a tree, when a bullet went through his helmet and another through his tunic, but he returned fire and killed the sniper. When he reached the enemy trench, they were taking cover, but his actions forced them to surrender and he succeeded in capturing a total of 102 prisoners.

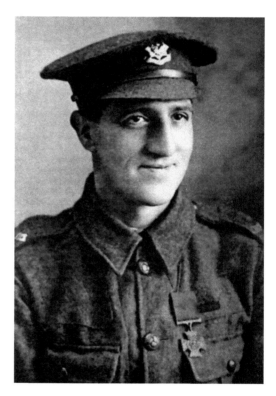

Right: Private Thomas Alfred Jones VC, DCM, 1st Battalion, Cheshire Regiment.

Below: Private Jones rounding up his prisoners.

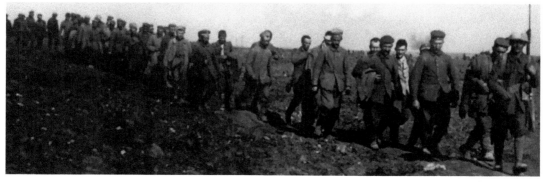

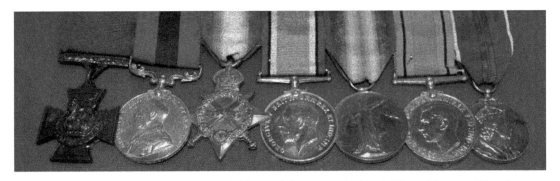

The medal set of Private Jones VC, DCM, held on exhibition in Cheshire Military Museum: Victoria Cross, Distinguished Conduct Medal, 1915 Star, British War Medal, Victory Medal, Defence Medal, 1937 Coronation Medal, Coronation Medal 1953, and Territorial Efficiency Medal.

When the news came through that he had been awarded the VC, he was given leave to be presented with his medal by King George V at Buckingham Palace on 18 November 1916.

From the palace he headed home, still unaware of the magnitude of the reception that awaited him. Todger Jones was now a deserved star of his day and truly worthy of his increasing fame. The local correspondent for Runcorn wrote,

> The Merseyside town was agog with excitement when the gratifying news became known on Thursday. The residents of Princes Street, where the hero's parents live, vied with each other in decorating the humble thoroughfare with flags, and people from all parts of the town thronged the Jones' house, anxious to offer congratulations at the earliest possible moment. Among the messages of congratulation received was one from the officers of Chester Castle, while Private Findlow of the staff of the Castle and a personal friend of Private Jones, came to Runcorn specially to convey his own good wishes.
>
> *Chester Chronicle*, 28 October 1916

Writing to his parents ahead of his arrival, Thomas wrote,

> My wound is nearly better. It was in the shoulder. I would not leave the battalion, and have been in action twice since. God again has cared for me, and guided me through all dangers. It seems as though your prayers for my safety have been more than answered. In our last action, when we took a certain village, I was extremely lucky. We had taken the position and were digging in. I felt the bullets passing me. I knew they would get me if something was not done, so I went across. While going, a bullet passed through my steel helmet, and four more through my jacket. When I got there I soon settled them. Some of them shot at me from their dug-out entrance until I settled accounts with them. The rest was easy, they started flinging their arms up, and I soon got the fear of God on them. Two of my chums then came across, and helped me get the Germans away to our lines. We took 120 of them back with us. I got a little shrapnel wound in the neck while in our barrage, but it was not much and I'm alright now. I am sorry Arthur's head wound still worries him. Leave starts for us shortly, and I am well up in the list of those entitled to it.

His brother Arthur, who volunteered for the Cheshire Regiment on 3 September 1914, was in France with the 10th Battalion on 25 Sep 1915, but within days had received a gunshot wound on 6 October, causing a depressed compound fracture of the skull. Back on home soil for hospital treatment by 23 October, he was still unfit for duty by 31 May the following year when he attended a medical board examination. Two weeks later he received his official discharge on a pension on 16 June 1916. Sadly, he continued to decline and passed away on 30 July 1917 aged thirty-three, and was buried in Runcorn Cemetery.

When Private Jones arrived home, thousands met him upon his return, and later a marble tablet was set up to record his deeds. His employers provided his parents with an annuity of £50 per year, and he received a host of gifts. There was more to come. Private Thomas Alfred Jones VC had been granted a civic reception at the home of the regiment in Chester. The car arrived at Princess Street on the morning of 20 November 1916, and under the escort of Sir Frederick Norman, Thomas sat on the back seat between his parents.

On arrival in Chester, the citizens had turned out in their thousands and he was received by the Mayor Sir John Meadows Frost and the city Corporation at the reception, while the Cheshire Regiment held a special parade with marching band in his honour. Tommy and his parents were then driven through the streets in two cars, his parents in the front and Tommy behind, with the mayor. On arrival at Chester Castle, he was received by Sir William Pitcairn-Campbell, General Officer Commanding-in-Chief of Western Command, and his staff officers. Sir William addressed the gathered crowd on Castle Square and praised the training Tommy had been given in shooting skills in the volunteers and Territorials. Following the official civic reception and dinner hosted by the Cheshire Regiment, he was again presented with gifts, which together with those from his home town amounted to a gold wristwatch, a silver teapot, a case of cutlery and a pair of field glasses, an illuminated address, framed photographs, a smoker's cabinet, a silver wristwatch, and a host of other items. He was also chaired round the Castle Square, and been photographed and filmed – a *Pathe News* clip that remarkably still exists and can be viewed on YouTube.

Before his return to his battalion, there were a raft of engagements to attend to, including a visit to the munitions factory in Helsby the following day, where he praised their contribution, telling the workforce their efforts were appreciated by all those at the front, which understandably went down to great cheers. He appeared at concerts and fêtes where his autograph was becoming well sort after, so much so that he signed his name for auctions to raise money for the local war effort.

While Thomas was still at home on leave, journalist A. E. Littler was despatched to Runcorn by *World Wide Magazine* to find out the full story of his brave deeds for their readers. He met him in his home and tried to get Jones to share his story in more detail than had so far appeared in the press:

> Brown-eyed, lithe, clean-cut, and on the slim side is 'Todger,' keenly intelligent, with a streak of fatalism in his composition that has sustained him through untold trials, modest as the

true hero always is, humorously tolerant of the worship he is commanding, lavish in praise of his comrades, yet reluctant to speak of himself.

'Surely,' said he, 'there has been "nuff" said, more than enough, of a thing that was done on the spur of the moment by a man who kept his head and knew how to use his gun. But if you want to know what I did, let the official account speak for me.'

Thomas handed Littler the official citation recorded in the pages of the *London Gazette* on 26 October 1916:

No. 11000 Private Thomas Alfred Jones, Cheshire Regiment. For most conspicuous bravery. He was with his company consolidating the defences in front of a village, and, noticing an enemy sniper at 200 yards distance, he went out, and, though one bullet went through his helmet and another through his coat, he returned the sniper's fire and killed him. He then saw two more of the enemy firing at him, although displaying a white flag. Both of these he also shot. On reaching the enemy trench he found several occupied dug-outs, and, single-handed, disarmed 102 of the enemy, including three or four officers, and marched them back to our lines through a heavy barrage. He had been warned of the misuse of the white flag by the enemy, but insisted on going out after them.

'Won't that fill the bill?' Jones said to Littler, but the journalist told him his readers wanted the story in full, and that it ought to be set down for the benefit of posterity. With a sigh, Thomas sat back in his chair with an air of resignation, then smiled, and began his astonishing story:

It was on September 25th that we took a village that I am forbidden to mention by name, and were just beginning to dig ourselves in near a wood, when bullets commenced to whiz past us, wounding one of our men in the head, and making things decidedly uncomfortable. I felt the bullets ping-pinging by me, and I said to the officer 'They're going to make it hot for us, sir. if we don't get after 'em. Can I get out and have a packet at them?'

'My orders are to consolidate this position,' replied the officer. 'You must not go an inch farther, and you had better get on with your digging.'

And dig I did, but as I got up again I saw a chap hit through the head and another through the thigh. Looking ahead, I saw what appeared to be a white flag, and that fairly riled me. My dander was up, and I shouted to the officer, 'What do you think of that, sir?' 'You must get on with your digging, Jones,' said he; but up I jumped, and called out, 'If I've got to be killed I'll die fighting, not digging.' I waited no longer, but dragged out my rifle, flung down my entrenching tool, jumped out of the trench, and went across.

The Huns were a couple of hundred yards away, and they could see me coming. One bullet went 'ssss' through my steel helmet, and four more through my jacket. There was a sniper in a tree, but I soon counted him out. On I went, and reached a bay, or traverse, leading to the German trench. There were three men in it, but jumping in at the end of the trench, I had only one at a time to deal with. I got my back to the wall, and they whipped round on me. I always believe in firing from the hip, and very quickly number one dropped dead.

Before the next man could recover his senses, I had shot him as well, slipped another cartridge in the breech, and got the old magazine going on the third at a yard range. The other men fired at me from the entrance to the dug-outs, but I managed to 'get there' first every time, which is a great thing in jobs of that kind. In the second traverse there were five chaps standing behind one another. One of them made for me with his bayonet, but I bowled him over like the others by the old trick of shooting from the hip.

I got the five of them, and some of them made awful noises, screaming and squealing. I stalked through the trench, storming and shouting, and, hearing the firing and the commotion, the rest of the crowd bolted into the dug-outs. Soon they had all 'gone to earth,' and I was there alone. When they got into their dug-outs I had them. It was just as if you were in a coal-cellar and I was in the street waiting to pot you as you came up. They were shouting and screeching, and every time I saw a movement I let fly.

Eventually they quieted down, and seeing some of their bombs, a pile of them, on the floor of the trench, I picked up a couple and sent them flying down the first dug-out, and they went off all right. Did I tell you that I was a bomber? I think they felt that the game was up when the bombs began to drop amongst them, for out rushed three fine specimens with their hands up and the usual cry, 'Mercy, kamerad!' They had left their equipment behind them to show there was no monkeying, and though I felt like laughing at being there all on my own, I demanded, in a stern voice, if any one of them could speak English.

One of them called out, 'I can.' 'Well,' said I, 'what's it to be? Do you want to be killed or taken prisoners? You can have it either way you like, for I'm not particular. In fact, I would rather kill you.' And all, with one consent, actually cried out that they wanted to become prisoners – and with Private Jones as their jailers, too!

I looked round and saw a hollow, so I told the English-speaking German to order his two mates to get in there. They had to climb up to do it, and I knew our chaps would see them from our trench as they got on top. 'How many more are there down the dug-out?' I asked, and the Boche answered, 'About fifteen.' 'What about it?' I said, and he replied, 'What do you mean?' 'Do they want killing or what?' said I, and he gasped, 'I don't know.' 'You know they're no use?' I said, and he replied, 'Yes, they're helpless now.' 'Well, then,' said I, 'go and tell them what I have told you – that they can either be killed or taken prisoners, and they can bloomin' well please themselves about it.'

And, by gum! He went and told them, and came back to say they would all be taken prisoners. 'Well, then,' said I, 'tell them they can come out when you call, but only one at a time, remember, and any one of 'em that has as much as a penknife on him, or any equipment, will be shot dead straight away. Fetch 'em up one at a time, and tell them that my mates are coming across in thousands in a couple of minutes, and if they find anything wrong with me they'll cut you to bits.' I heard him yowling down the dug-outs what I had told him, and, meanwhile, I got round the cover.

Presently he came back, and said, 'Are you ready?' 'Yes,' I replied; 'call them up, and only one at a time, and no rushing.' He shouted the message, and ordered them out without equipment. There were eight or nine dug-outs in all, and they kept tumbling out, and, as they came, I sent them out of the trench into the hollow I've told you of.

Lord! I'd expected fifteen and out they came in scores, and went into my 'compound'. When they were all out, I threw some of their own bombs into the dug-outs to make sure

that there was no sniper left behind to 'do me in'. And then I said to myself, 'Great Scot! What am I going to do with this little lot?' I knew I could eventually rely upon somebody coming from our trenches, but it was necessary to gain time.

It's not that I want to brag, but I didn't turn a hair; I just kept my head-piece going. I told them it would be a very cold night at the place where they were going to, and suggested they had better get their great-coats. I graciously permitted them to fetch them – 'two at a time, and no rushing'. They ran, and came in and out, and each time they passed me they saluted me – Private Jones! and I sent them to their places. I didn't like the look of one bloke, and kept half an eye on him. 'I think I'll shoot that chap,' I said to the interpreter.

'Don't,' he exclaimed, 'he's very good man.' But presently the 'very good man' went for his great-coat, and when he had got a short distance he made a dash for liberty. I swung round, clicked my rifle, and got him fair and square. He rolled over and over just like a rabbit. It was a snap-shot, but I put one through his head. Then, I turned to the German by me. 'Ask them if any more would like to try to escape,' I said. He did so, and they all jumped up – they were seated on the ground – flung up their arms, and shouted 'Kamerad!'

It fairly tickled me to death, that did, and I couldn't stop laughing. Why? Well, a bit of fun I once saw at a pantomime flashed through my mind. A comedian who played the part of the squire, revolver in hand, rounded up all the servants, male and female, butlers and gardeners, and up went their hands. Then he came to the grandfather clock, pointed his revolver at it, shouting, 'Hands up!' and immediately the hands of the clock whizzed round.

Well, I tell you I roared with laughter at the thought coming into my mind at such a time, when I was playing a lone hand, for it looked so comical to see them all with their hands up – over a hundred of 'em, hoping against hope that Private Jones, 'Kamerad,' wouldn't shoot.

I wondered what was going to happen next, for it was out of the question that one chap could keep them there for any length of time. But the bowling over of the chap who tried to escape was the best thing that could have happened for me, and it fairly put the fear of God into the rest. The official report speaks of me bringing in a hundred and two, but, though I didn't check their numbers, there must have been nearly a hundred and fifty of them when I got them into the open, including four or five officers and any number of non-coms, or whatever the Germans call them. But before they got into our lines, over forty of them were killed by our shells, which were sweeping the ground and clearing things up generally.

But I'm over-running my story. I had scarcely finished laughing about the clock putting its hands up, when I saw somebody start from our lines. It was my chum coming to look for me. He had been asking where I was, and, when they told him, he said: 'If Todger's across there I'm going to fetch him, dead or alive!' They all thought I was a 'goner', but, when they saw my chum start, three more chaps – a sergeant-major, a corporal, and a stretcher-bearer – came across with him. Seeing I was alive, my chum gave me a smack in the face, and couldn't stop larking.

They helped me to round-up the 'bag', and we marched them back to our lines. All the time our guns were knocking the position to bits, and, as I've said, some of the shells dropped amongst the prisoners and killed them. I got a shrapnel wound in the neck from our barrage, but it wasn't much. Strictly speaking, I suppose I ought never to have been in the game, but I wouldn't have missed it for world. When I went over my arm was a bit painful, for I was wounded on September 5th, and had refused to go into hospital.

Looking back, and thinking over the incident, I feel that I must have had what the poets call 'a charmed life', for after jumping out of the trench, and before I had accounted for the sniper in the tree, a bullet went through my helmet, and was buzzing round my head-piece like a marble in a basin, finally galloping down my back and burning me during the journey. Four or five other bullets passed through my tunic, but I wasn't aware of it until afterwards. It never entered my mind that I should be killed, and I didn't think my time had come.

Asked if he could explain how he was led into the exploit, Todger said, with a grin, 'When I saw the first three men in the bay, I knew I was up against something, but I had been in more than one tight corner before, and I had learned that the art of warfare – for the individual, at any rate – was to size up a situation quickly, to fire without hesitation, and hit your man.'

'And,' inquired the interviewer, 'was there no period during the incident that you felt that the proposition was too big for you?'

'I should be lying,' was the answer, 'if I didn't admit that I was glad, jolly glad, to see my pals come over, but I was cool as cool could be, and the lesson I applied was never to lose this (significantly touching his head). The man who loses his 'nob' is done for. I knew if I had to go I should, for everybody has his time, that's what I believe, and I meant to sell myself at a good price. But when I got the first men in the traverse, and drove the others back into the dug-outs, I felt that the game was in my hands. I had them at my mercy; they didn't know I was unsupported; I cowed them into submission to my orders; I pictured the end that awaited them if a hair of my sacred head was singed, and my trump card was played in making them come out one by one without any equipment.'

His interviewer was at pains to note that Private Jones was 'terribly reluctant' to speak of himself and had to be pressed to divulge more of his exploits. He revealed that on two or three other occasions prior to his raid on the German trench, he had been promised special mentions in reports, but the officers who had noted him were killed before the opportunity of recommending him for honours arose.

'It isn't every heroic deed that is noticed,' said the soldier. 'Many's the chap who earns the VC who never gets a "Thank you." Every lad out there is winning, though not receiving, glory; they are brave, noble, clean fighting, staunch and true men, and if they haven't had my luck they've deserved it.

But if you want to know what further part I have played in this war, and my preparation for the big slaughter, I may say I was an old Volunteer of the Cheshire Battalion, and that the skill I acquired as a marksman sixteen or seventeen years ago led to me being employed at the Front as a sniper and bomb-thrower. By trade I am a fitter, and am thirty-six years of age, and I tried to join the Engineers at the outbreak of war, but as a Territorial Reservist was eventually posted to the Cheshire Regiment, and found myself at the Front in January, 1915.

Amongst the narrow shaves I have had, may be included a bullet through my pouch, the heel of my boot blown away, and an explosion of a shell which lifted me ten yards in the air and lodged a piece of shrapnel in my shoulder and another piece in my knee.

Hill 60 [on the Ypres Salient in Belgium] was one of my hottest trials, and there I had my first experience – second hand, fortunately – of the German poison-gas. We had only been relieved the night before, and wanted a rest badly, but at ten o'clock in the morning

we received word that something had happened at Hill 60, and it was up to us to try to set it right. We got through Ypres town to the railway cutting, and there came under heavy shellfire. Bad wasn't the word for it, for they were bowling the lads over right and left, and as we got closer and closer their machine-gun fire was mowing us down something cruel.

Eventually we took cover in the railway cutting and met the Germans coming along four deep. We received orders to charge, and cleared them off the railway line, and then we had to start with the trenches. No sooner had Colonel Scott given the word, as he stood by my side, than he dropped mortally wounded. We didn't wait for further orders, for we saw red, and cleared the second line of trenches. Then we made another charge, and took the original trench, which had been held by the Dorsets.

There they sat, staring at us. "Matey, you're relieved," we said to one, but there was no answer. "There's some hot tea waiting for you in Ypres," we said to another. No answer. They were dead-gassed – and we didn't know then of the diabolical device that had killed them. I was one of forty-three that went out that night to bomb the Germans, expecting that another regiment would take over the trenches from which we had driven the enemy.

We used up all our bombs, and the Germans began to bomb us in turn. Our lieutenant was the only man with a revolver, and he used it until he had no more ammunition left and was shot. All except three of us and a corporal were either killed or wounded, and the corporal asked me if I could lead them back. I did it, and reported to the company officer, who said he had received reports on which he was going to recommend me for honours. A brave officer – reported from that very day as missing, as was the lieutenant.

We also went through the Battle of St. Eloi, which lasted three weeks. We were at Hill 60 when it was blown up, and we remained in the trenches for twenty days, and after just one night out put in another forty-three days, which constitutes a record either in the French or British Army for continual fire-trench work. We were even reduced to the necessity of sewing sandbags together to serve as a change of 'linen'. When the hill went up it was a sight one can never forget, while the shelling of Ypres was more like a mighty firework display than anything else.

The first trenches I was in were only thirty-five yards from the Huns. We caught a squad of them working in the rear of their trench. We soon downed them, but the others spotted us, and rattled at us for forty-eight hours. We dared not show our heads above the trench, but I was acting as guide, and one night I turned out to look for a N.C.O. who had been sent with a message and had failed to return. He had had to go through two woods in the dark, and I made sure he had lost his way. I took the turn he would have done had he gone wrong, and after going about two thousand yards I stepped through a gap in the hedge and got a nice little shock.

Lying on the ground about a yard from me were three Huns with helmets, rifles, and full kit! I whipped my rifle from my shoulder and butt-ended it, meaning to make a good fight for it. I noticed they did not move, so I stepped closer in, and saw the frost on their packs. Then I knew they were dead.

My first thought was souvenirs. I got in between the dead men, and was going to begin collecting, when a star-shell went up, and I soon found I had landed between our own lines and the Germans. They spotted me, opened rapid fire, and sent up light after light. I flung myself into a ditch and waited about ten minutes. I don't know how I escaped being hit, for the bullets struck all around me. All thought of souvenirs had gone out of my head. When they ceased I made a sprint for it. I did 'even time' that night, and was mighty glad when I found the missing NCO.

At another place we had a very rough time of it. Hell seemed to be let loose, for shells were dropping into our trenches, mortars blew the bags down, we were under rapid fire from the German trenches, and to cap the game they had mined the trench and tried to blow it up, but they had gone too deep, and only one or two of our lads were buried, and were safely dug out again.'

Pausing to recollect his thoughts, Private Jones placed his VC and a silver-edged German Iron Cross on the table between them. He looked at the two medals and then turned and fixed his eyes on the large official photograph of himself and 102 captives, then to his gold watch, a silver teapot, an illuminated address, and other public tributes to his valour, whereupon he remarked, 'Next to the VC, I think more of that Iron Cross than of all the rest, and God knows how much I appreciate all that my fellow-townsmen have done for me. But it's quite another story,' he said, when he was again pressed to reveal more.

'I won that Cross in a single-handed joust with a company commander of the First Prussian Guards. And I don't think the poor chap had ever had the chance to wear it! But he had to go, for there was only him and me for it, and I didn't see why Jones should be turned down.

The fact is, it was the last scrap I was in before I won the VC, and it was there that I got wounded in the shoulder. I don't think there's any harm in telling you it was at Guillemont-Mouquet Farm and the stronghold around. [On the Somme, near Thiepval]. The Germans had beaten back all attempts to take it from them. Division after division had tried to wrest it from them and had failed.

Then they brought up our division, and once again we were told that we had been called out to do what others had failed to do. It was a terrific struggle, and we were repulsed four times. Our company had to take the lead at the fifth charge. The bombers won through and leaped into the trench.

We knocked the machine-gunners over and helped the following waves to get through with little loss. It was a terrible journey – the worst, I believe, that I have been through.

Yes, I'm coming to the Iron Cross by degrees. I had a wild three minutes, a rare good do. We got rid of those about us, and I rushed into the next traverse and met my man, a fine big chap, full of fight, a commander of the swell crowd, the First Prussian Guards.

He made for me with bayonet, but I knew too many tricks even for a Prussian Guard, and I soon settled him. The Iron Cross, in its little case, fell from his inside pocket as he dropped. It's new; I suppose he'd just received it from the Kaiser. Poor beggar! I'll never forget him when I look upon the Cross I won from him in fair fight.

We were then reinforced, and advanced another three thousand yards past Guillemont and dug in, being too exhausted to go any farther. We stayed there until relieved in the early morning, when we went into support about six hundred yards behind, and the shelling was very heavy. It was here I got wounded. It happened in this way.

A party was lost, and I told them I would take them down for a drink, as they had been without food and water for over sixty hours. I got them to the place they had to stay at, got the water, and was making back when one of the big shells plumped alongside me and lifted

me about ten yards, a piece getting me in the right shoulder and leg. I refused to go down the line, and though my arm was useless for a day or two, and was a bit stiff and painful when I won the VC, it was all a streak of luck, for if I'd gone to hospital I should have missed the funniest round-up I've ever seen.'

He admitted that he was filled with pride when he was ushered into the presence of the king to receive his decoration. 'I was a bit flustered at first,' said Todger, 'but His Majesty made me at home. One of the first things he said to me when the record was read was, "How the dickens did you do it, Jones?" I won't tell you what I answered on the spur of the moment, but the King laughed, and so did I. It was just my luck, I said to His Majesty. I was like a man with his back against the wall, and I kept my head. And then I gave him an idea how the thing had been done, and he laughed at the thought of me fetching home my happy little family.'

After the Armistice, Private Jones was again presented to King George V on His Majesty's visit to Runcorn.

Private Jones also revealed the origin of his nickname:

I was afraid you'd come round to that, but there's no getting away from it. I was 'Todger' at school, and 'Todger' followed me to France. It's like this. As a boy at school I played football, and I suppose I was a bit tricky or artful when it came to dribbling. My school-fellows nicknamed me 'Dodger', but my front name is Tom, and it wasn't long before it was 'Todger' this and 'Todger' that. It was 'Todger' with everybody at the Front, and lots of 'em seemed to know me by no other name.

Astonishingly this was not the last of his heroic exploits. Rather less reported is the fact that he continued to serve with the Cheshires and earned a DCM, a further award for bravery, second only to the Victoria Cross. After a time recovering in hospital in St Omer from another wound on 4 August when he was also gassed, he was back in action the following month near Bapaume. While in the lines in Beugny on 28 September 1918, he went forward no less than five times through an intense military barrage to ensure messages got through. On some of his forays he also led stragglers to their positions.

11000 Private T. A. Jones VC, 1st Battalion, Cheshire Regiment (Runcorn). For conspicuous gallantry and devotion to duty. This man went forward five times with messages through an intense barrage. He also led forward stragglers and placed them in positions. His fine example and utter fearlessness of danger were a great incentive to the men.

London Gazette, 5 December 1918

After his discharge on 28 May 1919, Thomas returned to his pre-war job at the Salt Union Works (which later became part of ICI) where he eventually retired in 1949 after thirty-six years in the job.

During the Second World War he served as an ARP Warden and also in the Home Guard. On the 4 January 1956 he was admitted to Victoria Memorial Hospital, Runcorn, and passed away there just a few weeks later on 30 January. He was buried in Runcorn Cemetery.

Right: Private T. A. Jones VC, DCM meeting the king with the Lord Lieutenant of Cheshire, Runcorn, 8 July 1925.

Below: The statue of Private T. A. Jones VC, DCM, in Runcorn, which was unveiled in 2014.

Later that year on 16 May 1956, his sister, Emily Lightfoot, donated his medals to the Cheshire Regiment Museum. The set comprises the VC, DCM, the 1914–15 Star, British War Medal 1914–20, Victory Medal 1914–19, Defence Medal 1939–45, Territorial Force Efficiency Medal, George VI Coronation Medal 1937 and Elizabeth II Coronation Medal 1953. The exhibition also includes a number of souvenirs that were presented to him, several photographs, the Iron Cross and his hat complete with bullet hole.

As the centenary of the war and his brave service approached, a community-based appeal was launched to raise funds for a lasting memorial of Todger Jones, which would also represent the men who had served and returned home. Once the target was reached, a statue of Jones in bronze by Scottish sculptor David Annand was commissioned and sited in the memorial garden facing the town's main war memorial (on which his brother's name is listed). On 3 August 2014, following a parade and ceremony in front of the war memorial, the statue was unveiled by four veterans and active servicemen, and stands today to honour, in the words of the appeal's secretary Martin Kilduff, 'every serving man and woman that has returned from conflict only to feel forgotten. It is a mark of gratitude for the courage and bravery that they have given for their country'.

SECOND LIEUTENANT HUGH COLVIN VC, 9TH BATTALION, THE CHESHIRE REGIMENT

Born in Rose Grove, Burnley, on 1 February 1887, Hugh Colvin would also serve in the Cheshire Regiment and receive the highest and most prestigious award for gallantry in the face of the enemy that can be awarded to British and Commonwealth forces. In a battle east of Ypres, Belgium, when all the other officers of his company had become casualties, Colvin took command of both companies and led them forward under heavy fire with great success.

His parents were both from Aberdeenshire, his father working as a master gardener, who moved regularly to secure employment to support his expanding family. After moves in Scotland, the Colvins journeyed down to Lancashire, spending time in Burnley and Manchester, before settling in County Antrim, Northern Ireland.

After education at Hatherlow Day School, in Romiley, Cheshire, where he was keen on athletics and gymnastics, he worked for a time as a gardener in Lancaster, before leaving for Belfast where he moved in with his sister. Still restless, he enlisted in the 8th (King's Royal Irish) Hussars on 21 May 1908 and returned to England for training, before moving out to India with the regiment in 1909. After service in Lucknow Ambala until 16 October 1914, his regiment was shipped to France, landing in Marseilles on 11 November 1914. Serving now as a lance-corporal, he was commissioned as a second lieutenant and transferred to the 9th Battalion, Cheshire Regiment, on 13 April 1917 and attached to 9th Battalion.

By now, the battalion were on the Ypres Salient in Belgium, and Colvin received a commendation after his patrol party mopped up a series of concrete dugouts hidden

in a hedge near Messines on 15–16 June 1917, and also returned with valuable information about the location of enemy posts. However, it was his action later that year on 20 September east of Ypres that earned him the highest distinction. For this he was gazetted on the 8 November 1917, and presented with his VC on 28 November 1917 by King George V at Buckingham Palace. His citation reads,

> For most conspicuous bravery in attack. When all the officers of his company except for himself – and all but one in the leading company – had become casualties and losses were heavy, he assumed command of both companies and led them forward under heavy machine gun fire with great dash and success. He saw the battalion on his right held up by machine gun fire, and led a platoon to their assistance. 2/Lieutenant Colvin then went on with only two men to a dug out. Leaving the men on top, he entered it alone and came out with fourteen prisoners. He then proceeded with his two men to another dug out which had been holding up the attack with rife and machine gun fire and bombs. This he reached and, killing or making prisoner of the crew, captured the machine gun. Being then attacked from another dug out by fifteen men and an officer, one of his own men was killed and the other wounded. Seizing a rifle, he shot five of the enemy, and, using another as a shield, he forced most of the survivors to surrender. This officer cleared several other dug outs either alone or with his remaining man, taking about fifty prisoners in all. Later, he consolidated his position with great skill, and personally wired his front under heavy close-range sniping in broad daylight, when all others had failed to do so. The complete success of the attack in this part of the line was mainly due to 2/Lieutenant Colvin's leadership and courage.

During his period of home leave, like Todger Jones he too was given a civic reception at Chester, which took place on 2 December 1917. Arriving at Chester station just after noon, he was met by the mayor, the hall keeper, Colonel Cooke (commanding Chester Castle Depot) and the Chief Constable of Chester (Mr J. H. Laybourne). Also in attendance was General Sir W. Pitcairn Campbell (commanding Western Command). A waiting car then took Second-Lieutenant Colvin, with the mayor and Colonel Cooke, to the Eastgate, where they were met by the regimental band, which then led them through the lined streets to Chester Castle. There he was given a rousing reception by the troops on the parade ground, which after a speech by Colonel Cooke and three cheers for their VC comrade, he then inspected. After a lunch with the officers in the castle, it was then off to the Town Hall where the mayor had arranged a lavish public reception, remarkable in itself given he had only learned of Second Lieutenant Colvin being in England by telegram two days before. Nevertheless, all finery was present, with dignitaries decked out in their wigs and robes, and the chains of office and sword and mace bearers also evident, before a packed Assembly Room. More speeches followed and the mayor presented an address of congratulations, while the brass band struck up 'For he's a jolly good fellow' with all joining in. All too soon his leave was over and by the end of the week he was again back in France.

In the following March he was appointed a company commander and promoted to lieutenant later that year on 13 October. Still in the army after the armistice, he

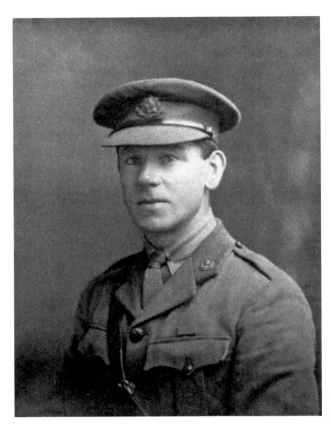

Second Lieutenant Hugh Colvin VC,
9th Battalion, Cheshire Regiment.

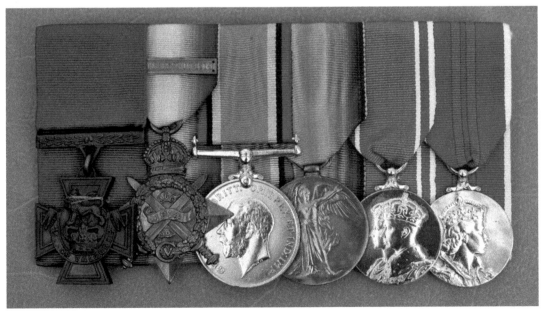

The medal set of Second Lieutenant Hugh Colvin VC, held on exhibition in Cheshire Military Museum:
Victoria Cross, 1914 Star with Mons clasp, British War Medal 1914–20, Victory Medal 1914–19,
Defence Medal 1939–45, George VI Coronation Medal 1937 and Elizabeth II Coronation Medal 1953.

was appointed supervisor of Physical and Bayonet Training, Army Gymnastic Staff, on 5 February 1919 and on 12 April was appointed assistant superintendent and chief instructor, School of Physical Training, Army of the Rhine. He held the latter appointment until 24 October 1919 as a temporary major. A year on, Hugh married Lilian Elsie Croudson at Christ Church, Blackpool, on 29 December 1920, and lived for a short time in Bispham, where they had a daughter, Marjorie Jean Marcie Colvin, born in 1923.

Hugh was a career soldier, and continued his service into the 1920s and '30s. He served with the 1st Battalion in India, where he was almost killed when a lorry overturned and careered down a hillside. In October 1927 he became a captain before he retired on 1 February 1935. However, with the Second World War looming and the need to build up forces once again, experienced men like Hugh were still needed, and on 1 June 1938 he was back in uniform again as a recruiting officer for North-Western Division in Chester and Preston as a local major, working under another VC recipient, Lieutenant Colonel Harry Daniels.

After the war he retired once more, this time finally in 1947, and he returned to his family in Northern Ireland. Hugh Colvin died aged seventy-five on 16 September 1962, and was buried at Carnmoney Cemetery, Newtownabbey, County Antrim, Northern Ireland.

During the First World War centenary commemorations, VC memorial stones were unveiled during remembrance services, which included local dignitaries and members of Hugh Colvin's family, in his home town of Burnley on 2 September 2017, and in the Carnmoney Cemetery, Northern Ireland, on 20 September 2018.

In Chester, a memorial stone to his memory lies in Chester Cathedral, where there is also a dedicated memorial chair. His medals, which along with the VC, include the 1914 Star with Mons clasp, British War Medal 1914–20, Victory Medal 1914–19, Defence Medal 1939–45, George VI Coronation Medal 1937 and Elizabeth II Coronation Medal 1953, are on exhibition alongside those of Todger Jones at the Cheshire Regiment Museum in Chester.

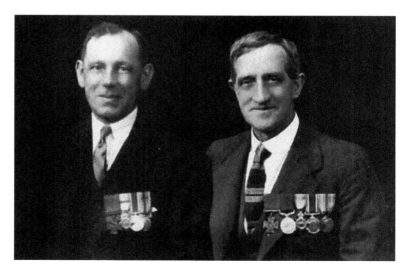

Two VC winners together: Second Lieutenant Hugh Colvin VC (left) and Private Thomas Alfred Jones VC, DCM (right).

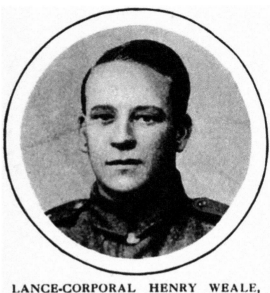

LANCE-CORPORAL HENRY WEALE,
Royal Welsh Fusiliers.

Above: Sergeant Henry Weale VC, 14th Battalion, Royal Welch Fusiliers.

Left: Memorial chair to Second Lieutenant Hugh Colvin VC, Chester Cathedral.

SERGEANT HENRY WEALE, 14TH BATTALION, ROYAL WELCH FUSILIERS

Born on 2 October 1897 in the humble dwellings of Ninehouses, Shotton, near Chester, on the Welsh side of the border in Flintshire, 'Harry' Weale was employed at John Sumners' Steelworks on the banks of the Dee after leaving school at the age of fourteen. At the commencement of hostilities, Harry signed on for the Royal Welch Fusiliers at Wrexham and rose to the rank of lance-corporal by the time of the action at Bazentin-le-Grand, France, where he carried out his heroic action on 26 August 1918. Harry, who was injured five times during the four years of war, went on to deal with three German machine gun positions. His actions inspired his company to advance and capture some fifty German prisoners of war and further machine guns.

The official citation read,

On 26 August 1918 at Bazentin-le-Grand, France, when the advance of the adjacent battalion was held up by enemy machine-guns, Lance-Corporal Weale was ordered to deal with hostile posts. When his Lewis gun failed him, on his own initiative, he rushed the nearest post and killed the crew, then went for the others, the crews of which fled on his

approach. His dashing action cleared the way for the advance, inspired his comrades and resulted in the capture of all the machine guns.

<div align="right">London Gazette, 12 November 1918</div>

For gallantry in the face of the enemy, he was awarded the Victoria Cross and promoted to sergeant. On his arrival home to Shotton he received a hero's welcome as soon as he stepped off the train, where crowds had gathered to welcome him, while the headmaster of his former primary school presented him with an illuminated address, which read: 'The parish is proud to know that one of its own boys has won, by deed of valour, the highest distinction which a British soldier can win.'

On St David's Day, 1 March, 1919 Harry travelled to London to receive his VC from King George V at Buckingham Palace while at home he was presented with a gold hunter pocket watch by his employers at John Summers. A few months later he was married, to Sue Harrison, and moved to Rhyl, his wife's home town. However, just as thousands of other returning soldiers found, it was not a land fit for heroes he had come home to, and soon found times very hard, especially with a poorly paid council job trying to raise three sons and a daughter. So much so, that he was forced to sell his John Summers gold watch. On hearing of his hardship, his former employers tracked down the watch, bought it and returned it to the family.

Harry died on 13 January 1959 in Rhyl at the age of sixty-four, and he was buried with full military honours at Rhyl Cemetery. In Queensferry, the TA headquarters is now known as Henry Weale VC TA Centre, while in Shotton, his birthplace, a memorial garden in his name was opened in 2010.

On Remembrance Day 2018, the crowds turned out again a century on in Shotton, to witness the unveiling of the VC paving stone bearing Harry's name (part of a centenary project to honour the 627 Victoria Cross winners of the First World War).

The Royal Welch Fusiliers Museum in Caernarfon Castle holds his medal set comprising the VC, 1914–15 Star, British War Medal 1914–20, Victory Medal 1914–19 with Mentioned in Despatches oakleaf, Defence Medal 1939–45, War Medal 1939–45, King George VI Coronation Medal 1937, and Queen Elizabeth II Coronation Medal 1953.

GROUP CAPTAIN GEOFFREY LEONARD CHESHIRE, BARON CHESHIRE, VC, OM, DSO AND TWO BARS, DFC

Leonard Cheshire was one of the most highly decorated servicemen of the Second World War, and later became further recognised as a philanthropist. The Cheshire family had long been established in the county of their name, having lived in the Northwich area from at least the late 1700s, with several of Leonard's family working in courts of law including his father George Chevalier Cheshire, who lecture in law at Exeter College, Oxford. His career was interrupted by war service when he returned home to serve with the 2/6 Battalion, Cheshire Regiment, and the Royal Flying Corps. He married on 6 February 1915, and he and his wife were

living in Hoole when Leonard was born on 7 September 1917. The family home in Hoole Road on the corner of Westminster Road, now a small hotel, bears a blue plaque on the wall to mark the event.

At the end of the war the family returned to Oxford, where Leonard's brother Christopher was born later that year. George Cheshire had taken a post at All Souls in Oxford where he would continue to have a distinguished academic career. Leonard was also educated at Merton College, Oxford, and graduated, like his father, with a degree in jurisprudence in 1939. Before any thought of continuing the family tradition, war broke out and he joined the Royal Air Force (he had already been a member of the University Squadron sine 1937). By March 1943, at the age of twenty-five, he became the youngest group captain in the RAF. In 1944 he was awarded the Victoria Cross after completing a hundred bombing missions on heavily defended targets in Nazi Germany.

The citation read,

> June 1940 to July 1944. From his first operational sortie on 9 June 1940 with 102 Squadron, through to his 100th mission at the conclusion of his fourth tour, he displayed the courage and determination of an exceptional leader. In four years of fighting against a bitter enemy, he maintained a standard of outstanding achievement, the result of superb planning and execution together with a total contempt for danger.
>
> *London Gazette,* 8 September 1944

Concerned with the rehabilitation of servicemen who had suffered injuries during the war, he became determined to set up a facility to help them recover and lead as normal life as possible. He founded a residential home for disabled ex-servicemen in 1948 at

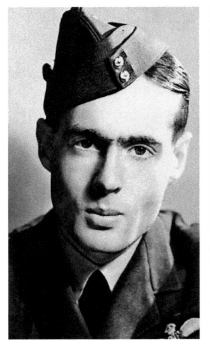

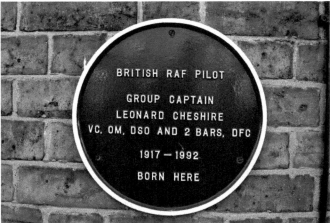

Above: Plaque at Leonard's birthplace in Hoole Road, Chester. (Lewis Royden)

Left: Group Captain Geoffrey Leonard Cheshire, Baron Cheshire, VC, OM, DSO and Two Bars, DFC.

Le Court, a large country house near Liss in Hampshire. By 1955 the charity, now known as the Cheshire Foundation Homes for the Sick, were running six Cheshire homes in Britain. The first overseas Cheshire home was established in Mumbai, India, in 1956. By 1992 there were 270 homes in forty-nine countries. Today the charity is known as Leonard Cheshire Disability. In recognition of his charity work he was created a life peer in 1991. Leonard Cheshire died of motor neurone disease aged seventy-four on 31 July 1992. Later that year the Queen paid tribute to him in her Christmas message.

Above: Leonard's birthplace in Hoole Road, Chester. (Lewis Royden)

Right: Munitions workers at Queensferry.

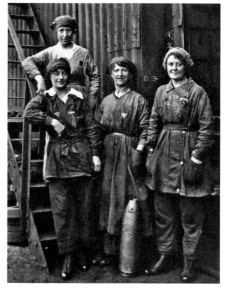

Training horses for the military on the Roodee.

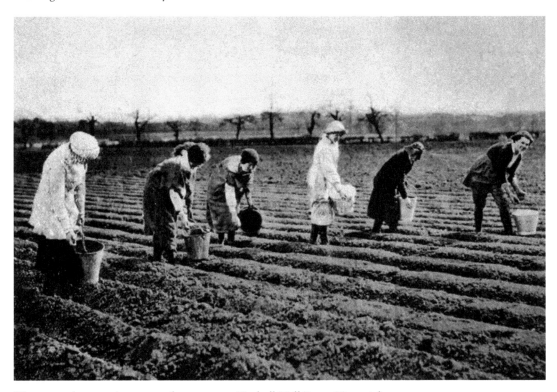

Women students setting out seed potatoes at Henhull Hall Farm, Nantwich.

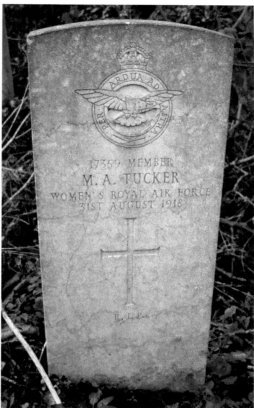

Above left: The grave of twenty-two-year-old Second Lieutenant Kenneth Alonso Nelson of the RAF, from Howard City, Michigan, USA, who already had several years' flying experience in Canada, and was only three hours away from an overseas posting. He had been flying for around an hour when his plane stalled on approach to Hooton Airfield and nosedived from 1,000 feet into a field in Little Sutton. He was rushed to Hoole Central Military Hospital in Chester with severe injuries, including two broken femurs and a fractured skull, but he did not survive the operation. He was buried with full military honours, escorted by a company of the RAF with reversed arms, while the band of the Cheshire Regiment followed the funeral cortege playing the funeral march. At the graveside in Overleigh, the firing party of the RAF sent out a volley of three shots, and played the 'Last Post'.

Above right: The Commonwealth War Grave in Overleigh Cemetery, Chester, of Member 17359 Marjorie Tucker, a driver with the Women's Royal Air Force who was struck and killed by a train on her way to RAF Sealand on 31 August 1918, aged thirty-two. She was buried with full military honours and escort, while servicemen and women lined the path both in the churchyard and at Overleigh. This was the first such occurrence of a servicewoman engaged in war work to be accorded such an honour in the city.

Chapter 6

Armistice and Home Again

Hardships at home had turned the community into a battle front in its own right. Faced with increased rationing, unemployment, air strikes and the devastating tearing apart of families, there was now a ravaging illness spreading across the country. There was concern in government, both local and national, as treatment seemed ineffectual, and it was beginning to reach epidemic proportions. In Chester it was reported,

> Cheshire has not escaped the new visitation of influenza, and up and down the country, some fifty or sixty schools are closed. The scourge seems to be at its worst in the Wirral area, practically all schools within ten miles of Birkenhead being closed, including the whole of the schools in Ellesmere Port. Communications from the Shropshire border indicates that the epidemic is notably prevalent there also. At one village four deaths have occurred in one family. Needless to say, the Public Health Authorities are taking all the necessary measures to check the spread of the malady. The public can help to fight this insidious enemy by avoiding all unnecessary risks of infection: for instance, by travelling as little as possible in trains and tramcars. On the appearance of the first signs of the malady, sufferers should endeavour to keep to their beds for a day or two, when no untoward result need be feared. Some excellent advice is contained in a memorandum on the subject, issued on Tuesday by Sir A Newsholme, MD, Chief Medical Officer of the Local Government Board, to local authorities.
>
> *Cheshire Observer*, 26 October 1918

Newsholme basically decreed that under the circumstances people 'stay calm and carry on' – a message that the press, local and national, were happy to reiterate. His advice in a world yet to see the NHS, sophisticated drugs and advanced medical science, reliance was placed on simple, yet effective measures. He merely advised people to avoid sneezing and coughing in public, and to keep plenty of fresh handkerchiefs on hand (the handkerchief to be 'boiled, or burned if of paper'). Other simple hygiene measures included washing one's hands and gargling with a disinfectant mouthwash.

Of course, the priority of the medical authorities was to avoid panicking the civilian population, especially as more than half of all medical personnel were occupied with military duties. As the epidemic spread, there were great demands for available medicines, and chemists reported a rush on quinine and other medications, sparking fears of panic-buying, it became clear that this silence could not be sustained.

Not all commentators shared Newsholme's opinion that preventive measures were pointless. Indeed, George Newman, the then chief medical officer of the Board of Education, was highly critical of the position adopted by Newsholme at the RSM meeting, describing him afterwards in his diary as 'vacillating' and 'incompetent', while the press reported,

> The influenza has got a good grip of Chester, though Dr Rennet gave it as his opinion yesterday (Thursday), that fresh cases were, as compared with the previous day, less numerous. There must be in the city some hundreds of persons stricken, and though working long hours at high pressure, the local doctors are finding it almost impossible to visit all the patients to whom they are summoned. As the work of the Medical Boards have been temporarily suspended, it is hoped some of the doctors who served on them will be able to give a hand to local practitioners until the epidemic has abated.
>
> *Chester Chronicle*, 2 November 1918

In the initial cases, recovery had been swift, and doctors at first called it the 'three-day fever', but it was soon apparent that this was no ordinary outbreak. Around a fifth of those infected developed pneumonia or septicaemia. In many cases death came devastatingly swift. Those who were fit and well in the morning could be dead by the evening. As it began to take hold, it brought about the highest mortality rate for any epidemic since the outbreak of cholera in 1849. In fact, worse was to come, and this evolved into a pandemic of the H1N1 influenza virus, infecting a staggering 500 million people across the world between January 1919 and December 1920. It even reached remote Pacific Islands and the Arctic. Statistics vary, but it was estimated that it killed between 3 and 5 per cent of the world's population, making it one of the deadliest natural disasters in human history.

Of course, the nature of warfare on the Western Front, the tight knit units, and huge troop movement undoubtedly increased the transmission of the virus, and may even made it more lethal. The fact that soldiers' personal defences and immune systems were at a very low ebb due to malnourishment, injuries, chemical attacks and battle fatigue, all increased their chances of infection.

Professor Roy Grist, a Glasgow physician, wrote about how deadly the infection was on 29 September 1918,

> It starts with what appears to be an ordinary attack of la grippe [so-called by soldiers in France]. When brought to the hospital, [patients] very rapidly develop the most vicious type of pneumonia that has ever been seen. Two hours after admission, they have mahogany spots over the cheek bones, and a few hours later you can begin to see the cyanosis [blueness due to lack

of oxygen] extending from their ears and spreading all over the face. It is only a matter of a few hours then until death comes and it is simply a struggle for air until they suffocate. It is horrible.

The authorities were ill equipped to cope with the epidemic, especially given the state of the nation's infrastructure after four years of war. Hospitals and staff were overwhelmed, and there was little they could do. Treatments were largely ineffective and there were no antibiotics against secondary problems such as pneumonia. The authorities may as well have shut everyone indoors and painted a cross on the front doors of infected houses. In fact, the fourteenth-century battle against the Black Death was further echoed, when public gatherings were discouraged, and town councils closed theatres, dance halls, churches and cinemas. Streets were sprayed with chemicals and people wore anti-germ masks. Some factories even relaxed smoking bans and allowed workers to smoke on site, believing that cigarette smoke would help prevent infection. Many schools began to close in early November.

DEATHS FROM INFLUENZA

The returns of deaths in Chester this week do not afford any hope that the prevalent epidemic has yet exhausted itself. Up to yesterday (Friday) there were 40 deaths from all causes, including 23 from influenza and eleven from pneumonia, as compared with 35 deaths last week, including 14 from influenza and eight from pneumonia. These figures show an increase of nine deaths from influenza and three from pneumonia. In the months before the epidemic appeared, the deaths varied from four to 15, the latter total being registered the last week in August and the first week in July. Several pathetic cases of deaths in the families have been reported. One householder in Tarvin Road has lost his wife and two daughters, the latter 33 and 24 years of age, another daughter being ill and a son in the Infirmary. An army pensioner (23) and his wife (28), who lived in Hugh Street, Handbridge, were carried off within two hours of each other. One young lady, who had the sad duty of notifying the death of her sister, was herself a few days afterwards reported dead.

Death has claimed numerous Chester victims of this scourge recently, among them being Ethel Nestor, wife of Mr John Mountford, of Gloucester Street, which took place last Friday, after a very short illness, at the age of 34. Much sympathy is felt for the husband, who is left with four young children. Mr Mountford is well known from his connection with the news agency business in Northgate Street and also as a prominent cricketer, playing for Eaton and also Boughton Hall. The funeral took place at Christ Church and the General Cemetery on Wednesday, the Rev. G.E.M. Bennett, vicar, conducting the service. There were many choice wreaths, and the funeral was attended by many representatives from the Queensferry Munitions Works where Mr Mountford is employed.

Another victim was the wife of Mr Gaston, of Richmond Terrace, who is also employed at Queensferry, on Saturday, who died at the age of 27. Being a native of Bexhill on Sea, the body was conveyed thither by rail and the internment took place there. The railway companies and large business houses in Chester are experiencing inconvenience in carrying on owing to hands being laid up with the influenza. Mt T. D. Harper of Hoole, Chief Clerk in the goods department of the L.N.W. Railway is down with pneumonia and Mr Hughes, goods agent, is also suffering from influenza.

The schools at present closed owing to the epidemic are St. Paul's Girls, Victoria Road, all departments, Cherry Road Boys and Infants, Egerton Street Infants, Handbridge, all departments, Hunter Street, Grosvenor St John's Infants and Trinity Girls. The County School for Girls reopened last Tuesday, but owing to continuance of the malady it was decided to close again. The Queen's School also remains closed till Nov. 12th.

Chester Observer, 9 November 1918

While all these valiant but futile attempts to contain the virus continued, the war had moved into its final phase and newspapers were carrying reports of Germany and Austria wanting peace talks. This too would be futile, as the Allies pressed on for outright victory. Finally, this came on 11 November 1918, when the Armistice was signed bringing an end to all hostilities. A few days later the local press reported,

JOYOUS CHESTER

Chester will not easily let fade from the memory Monday 11th day of November 1918. When the youngest generation has become in turn the oldest, children yet unborn will hear of the great tide of rejoicing that swept over the city when the glad message came that the Armistice had been signed. From half past eleven when the news came through, till after midnight, the city gave itself up to happiness and celebration. The fighting was over; the good days had come again! And this was the first good day for nearly four and a half years.

All the earlier part of the morning Chester was Chester – quiet and quaint – a happy hunting ground for historian and antiquarian, a military centre, the home for thousands of quiet English folk, who had borne uncomplaining, all the anguish, suffering and discomfort that came in with August 4th 1914. But Chester was not quiet Chester when the news came and spread. There are those who say it was rather like Bedlam, and there are others less given to exaggeration, who merely claim that neither Piccadilly nor the Strand could possibly have been more crowded than Northgate Street, Eastgate Street and Watergate Street.

But certainly, not more than five minutes had gone before the streets were ablaze with colour enough for a King's visit. There were flags everywhere. Workers sang 'God Save the King' and downed tools, shopkeepers rushed for their shutters, business men abandoned their offices, housewives left the dinners they were cooking, and the children came flocking out of school. The world, his wife and his children made merry and were glad!

Shortly after eleven o'clock a crowd began to gather in front of the Town Hall. It grew quickly, and while it waited for the official announcement, listened to the King's School Cadets, who, 'with blaring bugles and wild seductive drums', paraded up and down and around about.

Not only the city was be-flagged. The citizens themselves were part of the colour scheme. Nearly everybody had a rosette, a ribbon, or a banner, and mothers kept turning round to their children to ask 'Is the flag alright?' Soldiers, equally with maidens, sported colours, and the average regimental cap badge was smothered under big bows of red, white and blue. Just before midday, the crowd had become one of the largest seen in Chester for years.

Ringing cheers went up as the Mayor, Sir John M. Frost, the Sheriff (Alderman John Williamson) and Alderman W. H. Churton – all three in their robes – came out on to the Town Hall steps and looked down at the surging crowds below. The cheering and the excitement intensified when the band of the Cheshires and a military detachment from the

Castle came marching, or rather, fighting their way from St. Werburgh Street into the square. Flag waving girls and women, in happy hysterics, dashed in among the band boys, whom the bandmaster had great difficulty in keeping together. At least once he had to rescue his big drummer from the attentions of a hilarious lady and her banner who was nearly hoarse with shouting 'Good old 22nd of Foot', and what with playing his instrument, battling with the mob, and lending his senior a hand, one N.C.O. wore a look not often seen outside a barrage.

It was some while before the Mayor could get a hearing, for only reluctantly did those inclined to noisy jubilation refrain from cheering. The Mayor said: 'In common with the rest of the land, we are gathered together today to celebrate one of the most memorable events in our history. We must congratulate not only ourselves, but the whole world, on the fact that an armistice was signed this morning. After having borne the misery of the past four and a half years, with every bravery and fortitude, we can now rejoice that peace has come again. Let us preserve the joy that is in our hearts that it may enable us in days approaching to carry on the great work of reconstruction'.

His Worship read telegrams of congratulation he had sent to the King and the Prime Minister. 'The citizens of Chester', ran the former, 'send their loyal congratulations to his Majesty on the signing of the armistice, and record their grateful thanks for their heroic services of the Navy, Army and Air Force, and express the heartfelt wish that there is a lasting peace for the world has dawned'. The one to the Prime Minister was a message of thanks for all he and his Cabinet have done for the Empire.

The Mayor, in proclaiming a public holiday, said that all hearts went out in gratitude to the noble army Marshall Foch had the privilege of commanding, and to the wonderful Navy that had protected our shores.

Excitement reached a climax when Lieutenant Colonel Cooke, Officer Commanding the Depot of the Cheshire Regiment, led cheering for the King. The old Cathedral in the background, in all its history of a thousand years, has surely never witnessed a scene of greater triumph and rejoicing. But it was not all revelry. There fell a sudden hush as the Venerable Dean of Chester (Dr. Darby) came forward and read a prayer of thanksgiving and afterwards recited with the crowd the Lord's Prayer. The stillness had a solemnity and significance, which told more truly than a thousand cheers of all, what the last day of the world war meant for England and the English. Could they but have spoken, surely the stones of the Cathedral would have cried out that the Englishman today was worthy of his forebears the crossbowmen of Cressy and the warriors of Waterloo.

THE KING TO THE MAYOR
His Worship the Mayor of Chester has received the following gracious reply to his message to the King:-

'Buckingham Palace.
The Mayor, Town Hall, Chester.
The King commands me to thank you and through you the citizens of Chester, for the loyal congratulations to which your message gives expression on the signing of the Armistice with Germany.
Private Secretary'

HOSPITAL AND THE NEWS

The good news was nowhere received with greater delight than in the military hospitals. The men were overjoyed to hear that 'it was all over', and that 'everybody's cheque' was merely a matter of time. At Hoole Bank, where there was a tea and a concert in the evening, one patient made a name for himself by suggesting that 'the roof should be lifted off' as a token of rejoicing. The men at Oakfield spent a very happy evening. After tea they had games, a concert and dancing. [Today, Oakfield is the hall now in Chester Zoo].

WITH THE CROWDS

As the day wore on the crowds increased and merriment waxed stronger. People cast aside the mantle of national reserve, and there were scenes of gay spontaneity more usually associated with the festivities of Latin Europe, than those with self-contained Britain. Indeed, there were moments when a spectator, looking down from the Rows might easily thought himself in Venice, had it not been for the fact that, even to the most widely imaginative, a roadway can't possibly look like a canal. Not that there was a single incident that wasn't good to look upon, for the truth is, that few people can honestly say that they say anything they would rather not have seen. If elderly ladies jigged in the streets, if half-a-dozen high spirited young officers played a barrel organ, if soldiers shouted and laughed, and if the girls frolicked with them – what of it? And, if a man from some wine merchants, forcing his way through the crowd with a basketful of bottles was eyed enviously, and eventually had a following who eyed his back and the bottles with envy, what of it? Still, it would be more than interesting to know whether, when he handed over, he was able to produce the full supply or otherwise.

Nearly everybody made their acquaintance of the lady who wore a tricolour flag as a cloak. She was dark rather than fair, she was well over forty and was very fat. Had she not footed like a Russian dancer, one might easily have taken her for a dowager-duchess. She had a word and a smile for everybody, and for every man who'd served the King she had a kiss, though it is only right to add that many of her proffered favours were not accepted. Hundreds watched with rapt attention while she interviewed a wounded soldier in a bath chair, exchanged her Stars and Stripes for his Union Jack, and pressed her lips, not on his, for he was a bashful sort of a fellow, but against his right ear.

Everywhere there were signs of all the day meant. Every man tells of a dozen things that made him laugh; every street could tell of a thousand. The quietest men were Americans, 'I didn't think English people had so much life in them', said one. 'I had always heard and had come to think that John Bull hadn't got it in him to get excited'. He laughed heartily at the reply from an old woman who overheard him. 'We've earned a little flutter lad, believe me', she said.

The wounded were lionised. They were patted on the back, shaken by the hand, and congratulated on the fact that their soldiering was over. And at the canteen there were free drinks all day! All afternoon, all evening and all night up to midnight, the celebrations continued, and the morning after the more sober minded citizens of one district complained ruefully of lack of sleep, owing chiefly to a vigorous chorus party who sang well into the early morning that gem from that grand opera, '*Nah-poo, toodle-oo, Goodbye-ee*'. [The popular wartime song '*Good-bye-ee*', composed by R. P. Weston and Bert Lee in 1915].

But only naturally, there were those whose rejoicing served to make a little sad – those who gave their dearest and best and lost them in the war, those for whom the coming of

peace will not bring all that they would long for. So there were sad faces in the crowds. There was one happening that should inspire a poet. There is no need to mention where it took place, or to say who was concerned in it, but there was one man, perhaps mourning comrades he cannot forget, who took off his hat and asked those around to give cheers for the dead. It mattered little that, in the exuberance of his joy, he swarmed up a lamp post. What did and does matter is that he remembered and wished to honour those who sleep on the field of honour. Nobody who heard him was offended, for, if he was a little ridiculous in himself, there was something sublime in his appeal. The cheers he asked for were given.

An amusing and spontaneous meeting took place on the Market Square in the afternoon of Monday. A party of American soldiers who had paraded the main street, followed by an admiring crowd of juveniles, marched up the steps of the Town Hall and a chosen member of the party addressed the assembly which had assumed large proportions. He said at this meeting, presided over by the Mayor in the morning, the mistake was that the people did not make sufficient noise. He therefore called for cheers for Peace, which were vigorously responded to. Another speaker succeeded to the honour of presiding, and after calling for cheers for the men in the trenches, he announced the hope that the Government would open the houses of refreshment at 4pm. The soldiers in merry mood formed in columns and moved off, amid the laughter and cheers of the citizens.

The employees at the different works downed tools almost as a matter of course on hearing the welcome news, and on leaving for the remainder of the day, broke into cheering, and in at least one instance sang 'God Save the King'. This was at the Hydraulic Works (Egerton Street), where a Mr Hobbs, managing director, called for cheers, which were given, and were followed by the singing of the National Anthem. The men at several works were still taking leave on Tuesday.

Cheshire Observer, 16 November 1918

Soldiers of the Cheshire Regiment returning home after the end of the war, Eastgate Street, 1918.

For the soldiers in the trenches the news was received differently, as silence spread over the battlefields for the first time in four years. In marked contrast to the euphoria on the streets at home, soldiers were more reflective and even dazed. H. G. Wells called it *The War That Will End War*, but the peace that was fought for was to be lost at Versailles, and the defeated would be back again in force within two unsettled decades.

Civic reception for soldiers of the Cheshire Regiment in Chester Market Hall.

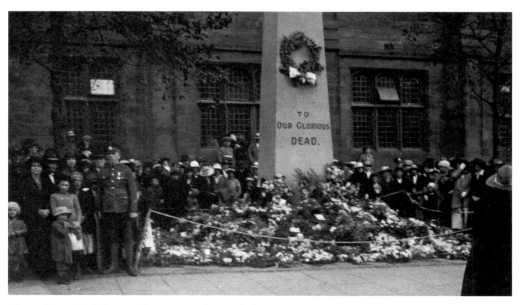

Chester Town Hall Square War Memorial, unveiled by two mothers in 1922 – Mrs Lydia Sheriff-Roberts, who had lost three of her four sons, and the other, Mrs Mary Beatty, four of six.

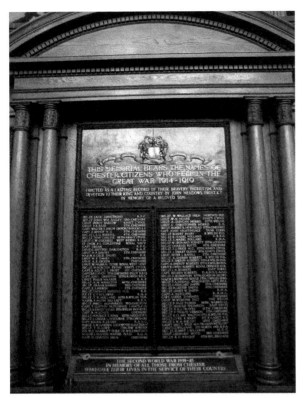

The centre panel from the citizens of Chester roll of honour, Chester Town Hall.

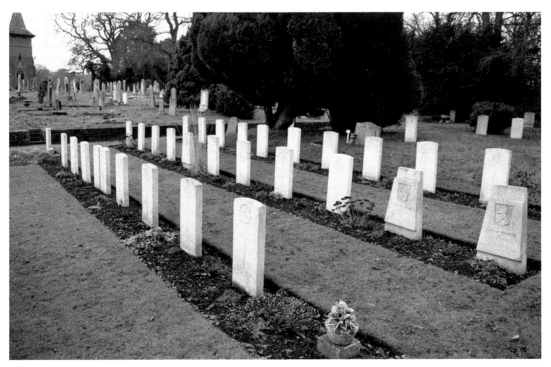

Commonwealth War Graves, Overleigh Cemetery (south). (Lewis Royden)

PART 2
THE SECOND WORLD WAR

Chapter 7

The Phoney War

As the storm clouds gathered once more, preparation for war was underway well before September 1939. As the international situation had deteriorated by spring 1939, the British government introduced the Military Training Act in May that year, which limited conscription to single men aged between twenty and twenty-two. This made provision for six months' military training, with around a quarter of a million men registering across the country. However, when war was declared on 3 September, Parliament immediately passed more wide-reaching legislation. The National Service (Armed Forces) Act imposed conscription on all males aged between eighteen and forty-one who had to register for service, although those under twenty could not be sent abroad. Those in essential industries, such as farming, engineering and medicine, were exempted, as were the medically unfit. A second Act was passed in 1941, which widened the scope further to include all unmarried women, and all childless widows between the ages of twenty and thirty. In addition, problems were arising due to the fact that nationally not enough men were volunteering for police and civilian defence work, or women for the auxiliary units of the armed forces. Consequently, men were now required to do some form of National Service up to the age of sixty, which included military service for those under fifty-one. By 1942, the requirements had changed again, and the age range for male British subjects was extended from eighteen to fifty-one, and men under twenty could now be sent overseas, plus all females aged twenty to thirty could now be called up (the age bracket now applied to those who had retired, resigned or had been dismissed from the forces before the war, and were now all liable to be recalled).

Meanwhile, government instruction leaflets and signage began to be circulated, giving clarification and advice regarding evacuation, the blackout, the use of gas masks, what to do in an air raid, and rationing (introduced in 1940). Radio and newspapers also gave out regular updated and advice. Identity cards were issued, and soon lorries arrived in the streets to unload Morrison shelters (for under

Above: Communal air-raid shelter on Upper Northgate Street, 1939.

Right: Air-raid instructions in the Chester press.

WHERE TO GO IN AN AIR RAID

CHESTER PUBLIC SHELTERS

In the event of air raids it is imperative that the public should co-operate with the authorities and carry out implicitly the instructions. The public should make themselves fully acquainted with the nearest public shelter, and with the quickest ways to reach it. School shelters will not be available for the public.

The detailed list of public shelters in Chester is as follows:—

Brook Lane.—Two trenches opposite the end of Liverpool-road (accommodation for 200).

Boughton.—One trench near the end of Hoole-lane (100); one trench opposite Richmond House (60).

Christleton-road.—One trench alongside the Peacock Hotel (100).

Crook-street.—One trench at the rear of the City Mission Hall (150).

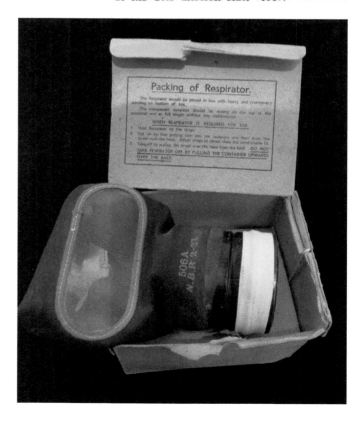

Gas mask. (Lewis Royden)

Left: Identity cards. (Lewis Royden)

Below: Ministry of Information Make Do and Mend campaign booklet.

kitchen tables) or outdoor Anderson shelter, depending what the household had opted for. Others had to rely on the communal shelters across the city, such as below the Grosvenor Museum or the Gaumont Cinema. The 'Dig for Victory' campaign saw back gardens, allotments, school playing fields and public parks turned over for the production of food. Petrol, furniture, and clothing soon became scarce and joined the list of rationed commodities. In the case of clothing, the 'Make do and Mend' campaign encouraged recycling on a grand scale.

An air-raid precautions committee had been established by the council as early as 1936 and set about training wardens and building shelters. Chester was already the base for the Army's Western Command centred in the Watergate building and associated offices towards the castle, but in 1938 the purpose-built classical headquarters was built in Queens' Park on an elevated position overlooking the river.

The demands on factories to contribute to the war effort resulted in many local manufacturing firms turning to war production, and employment was given a much-needed boost, especially in the Lache estate where many secured work in the aircraft factories. The Women's Voluntary Service, formed in 1939, was well supported in the city, but after the Act of 1942, more women became employed in local manufacturing and in the Land Army in the surrounding rural countryside.

By the time war had been declared, plans were already in place to evacuate large numbers of children at risk in the Liverpool area, and most would be travelling into Chester, from there to be put on trains or coaches destined for mainly rural destinations in Cheshire, Shropshire and across the Welsh border. A great many were to remain in the city and homes in Chester had to been urgently found. Eventually, the number of evacuees exceeded that of the local school population, and the only way of teaching them was to alternate on a half-day basis. Local people were frequently appalled by the poverty of the children sent to them they described as 'unclothed, diseased, and lousy'.

Evacuees wait
in a schoolroom
for the arrival of
their foster parents
(1 September 1939).

Evacuees enjoy a party in Chester during the Second World War.

In Cheshire, between 50,000 and 60,000 evacuees were received in four days. The local press reported (in the language of the day):

> Chester is becoming accustomed to the 'Dicky Sam' accent peculiar to Liverpool, and several thousands of children have been evacuated to the city during the past week. It is estimated that there are in Chester 3,000 children of school age, 2,500 children under school age with mothers, over 300 mothers, and a number of blind people and cripples.
>
> *Chester Chronicle*, 9 September 1939

Christina Laverty described leaving her home in Liverpool:

> In September 1939, my school organised our evacuation to Chester. We assembled at Lime Street station in Liverpool, each child equipped with a gas mask, our name tags and suitcases. I said a tearful goodbye to my mother (it was my mother who shed the tears) and I was off on a new adventure. I had not been any further than New Brighton before.
>
> We arrived at Chester and were given a bag of goodies at the station. We were then taken to Cherry Lane School to await the various people who were going to take us in. One by one the children were picked out and taken away. I began to worry, as the number of children dwindled down to just a few. I was starting to panic, then I saw a lady move towards me. She had a kind and homely face. We were introduced, 'Mrs Ledsham, this is Christina from Liverpool.' The waiting was over.
>
> Mr and Mrs Ledsham, lived in Christleton with their young daughter June, who was about 5 years old. They also had a lodger called Mr Jones. Both he and Mr Ledsham were

train drivers. During my time there I was well looked after. It was a happy home and I fitted in very well. The only blot on my stay was when the evacuees were taken to the health centre to have our hair washed in some sort of lotion and then covered with a cloth turban. We had to walk through the street with everyone staring at us. I cried my eyes out and would not venture out of the house. We were told to keep the lotion on for two days. The headmistress who was boarding across the road was called in to placate me. She explained it was just a precaution against nits. I protested loudly 'that I had never had nits and that my mother kept me spotless.' I said, 'Why are you not having yours done?' – after all, she was from Liverpool just like us. I was allowed to wash my hair and went out to play.

Sadly, I only stayed until a few days before Christmas. I went home for the holiday but my mother was not well and I never returned to Chester. I stayed in Liverpool until the May Blitz, when I moved to Tyn y Morfa in North Wales, but that's another story.

Christina Laverty, *BBC WWII People's War,* 6 April 2004

The early years of the war were the most dangerous for civilians, although a succession of air raids from late 1940 to early 1941 did little damage. Chester escaped the destruction and loss of life experienced in targeted ports such as Liverpool, Birkenhead and Hull, but on 28/29 November 1940 the heaviest raid in the county occurred. On the night when the main target was again the port of Liverpool (which saw the heaviest damage and loss of life so far), the most serious local incident was at the East Lancashire Sanatorium at Barrow a few miles to the east of the Chester. A mine fell on the main building, which was completely destroyed, including a number of chalets. Nineteen people were killed, and between thirty and forty seriously injured. Rescue squads from a wide area worked unceasingly to save people who were trapped.

One side of Foregate Street was ablaze, while the main damage was done by a parachute mine exploding in mid-air, which blew out hundreds of windows in the main shopping centre and the cathedral. The gas works was slightly damaged, and three houses demolished. A further fifteen were seriously damaged, but none were beyond repair. The Foregate Street buildings were completely gutted and remained derelict until after the war.

Although this was no doubt a terrifying experience for local residents on the night, it comes nowhere near what Merseyside endured through several months of pounding. Nevertheless, defence personnel still put in hundreds of hours of fire watching, patrolling streets during the blackout, and support in a variety of other necessary measures, as did the emergency services, the Home Guard and the voluntary services. The stress of not knowing what was coming was no less than in other more heavily damaged areas. Casualties were mercifully light, with only three people losing their lives as a direct result of the enemy attacks.

Cyril Dutton, a twenty-five-year-old local fireman, had been recently seconded into the Chester Auxiliary Fire Service from the Army. He was off duty on the night of 28/29 November, but reported in to lend his assistance. While trying to fight back flames caused by one of the many incendiaries dropped that night, he was hit by debris, crushed beneath a falling wall, and died from his injuries. He was laid to rest in Overleigh Cemetery.

A second victim that night was thirty-three-year-old Annie Gallagher, who was injured in the early hours of 29 November in Eastgate. Miss Gallagher, who lived alone at No. 9 Steven Street, Boughton, died of her injuries in the Royal Infirmary later that day.

The high explosive that landed on Crane Street near the racecourse on the night of 1 January 1941 claimed the third victim, Mrs Elizabeth Moore, aged sixty-four, of No. 9 Old Crane Bank, Crane Street, the wife of Thomas Moore. Mrs Moore was bedridden downstairs, while her husband, who was upstairs, escaped with superficial injuries. Their grandson, Peter, was taken to hospital with a head wound, but was not seriously hurt. The pitiful scene was described in the pages of the *Cheshire Observer* a few days later, with a strange emphasis in the headline, considering a life had been lost, unless the death was played down due to wartime conditions:

SAVINGS LOST IN AIR RAID
HOUSES DEMOLISHED IN NORTH-WEST TOWN

One woman was killed and three people were injured, when a German raider dropped a bomb on a North-West town. A direct hit was scored on some small houses, four of which were demolished, and the woman, Mrs Elizabeth Moore, was trapped under the debris. Fire was started among the wreckage by glowing coals hurled from the kitchen grate, and Mrs Moore's body was not recovered until about mid-day the following day. She was 66 years of age. Among the injured is Mrs Moore's nine-year-old grandson, who has a scalp wound. Others who are hurt and in hospital are Mrs Bertha Totty aged41; Mrs Sarah Jane Hughes aged 52; and her daughter, Kathleen Vera age 19. The two last named are believed to be suffering from burns, sustained when they were flung against the fireplace by the blast from the bomb explosion. Other cottages in adjoining streets were so badly damaged that their occupants had to be moved to fresh homes.

A PITIFUL SIGHT

It was a pitiful sight that met the eyes when daylight broke. The ruins of four, clean, working-class homes were roped off, their walls and roofs reduced to heaps of dusty rubble. In the street were piled all the furniture and bedding the rescue squads had been able to salvage, and as the steel-helmeted men toiled and laboured, other pathetic little items were added to the mounds.

Heavy-eyed women, tired and still dazed by the tragedy that had stricken them, gazed at the shattered ruins of their homes, and the feet of curious sightseers crunched on the glass that littered the streets. Just around the corner from the four houses completely demolished, were others with their windows blown out and their doors torn off by the blast. Their floors were strewn with plaster, and the furniture was scarred and dusty. Curtains hung forlornly from the frameless windows, and flapped in the breeze. In one room of a damaged house, a bowl of goldfish still occupied its usual position on the narrow shelf, and the fish swam around in ever questing circles. Next door, two lively budgerigars chirped and hopped about their cages, until someone covered them with dark cloths. One of them was the pet of Mrs Hughes, who was injured, and when she was rescued and taken to hospital she repeatedly enquired anxiously as to whether he was safe. Among the articles brought out was a dog basket. The dog was saved too.

A PATHETIC FIGURE

One of the most pathetic figures was Mrs Moore's son. He had been at work all night, and knew nothing about the destruction of his home or his mother's death until he arrived there after finishing his shift. 'My home's gone, and my mother with it.' He said brokenly. 'I've lost everything – all my savings too.' He was shocked and bewildered, and glances of pity followed him as he wheeled his bicycle away, to seek help and advice.

An elderly woman clutched to her chest a few belongings she had quickly sorted from the wreckage, and walked with quick little steps up the street. Her face was still lined and grimy with the soot that showed on her when the bomb fell. 'It was terrible,' was all she would say.

Twenty-five pound notes, destroyed by the fire, were picked up among the debris. On the night of the raid, the homeless were temporarily accommodated in a rest centre, where they were given tea and food. 'I went along to give a hand, and was impressed by the fact that no one seemed frightened,' an official said. 'Most of them were as black as n____, from soot and dust, and nearly all were in their night clothes, with overcoats thrown over them. One girl said she was in bed when the ceiling fell in on her. Wardens and WVS helpers took care of them, and most of them found homes with friends the next day.

Cheshire Observer, 4 January 1941

Throughout the war there were 232 alerts: forty-four high-explosive bombs and three parachute mines were dropped on the city, plus 168 incendiaries. On 28/29 November 1940, the worst night of the bombing, two people were killed and nine seriously injured. Official Records (held at the Imperial War Museum) reported the full extent of the raids on Chester and the casualties.

Date	Bombs	Location	Casualties	Damage
1940 29 Aug	9 Incendiaries	City Hospital, Station Road and Oulton Place		Small fires – but non requiring Fire Service
25 Sep	1 High Explosive	Field near Blacon School		none
25 Oct	19 Incendiaries	Handbridge Area		Slight damage to roof of one house
18 Nov	3 H.E. Bombs	Highfield Road, Blacon		Slight damage to residential property
28 Nov	21 H.E. Bombs 2 Para Mines 168 Incendiaries	Various places in Chester	2 Killed 9 Casualties	Gasworks, slightly damaged, 3 houses demolished, 15 houses seriously damaged, but not beyond repair
1941 1 Jan	1 H.E. Bomb	Crane Street, adjacent Gas Works	1 Killed 5 Casualties	Gasworks, slightly damaged

Date	Bombs	Location	Casualties	Damage
7 April	3 H.E. Bombs (1 UXB) 65 Incendiaries	Queens Park area	1 casualty– a woman in Seaville Street, injured by a shell	29 houses seriously damaged, including warden post, 90 houses slightly damaged, electricity supply interrupted
15 April	11 H.E. Bombs 83 Incendiaries	Roodee Racecourse		Very slight
22 Oct	4 H.E. Bombs	Sewage Works, Sealand Road		24 feet main, 36 feet main, plus 2 settling tanks damaged
25 Oct	1 Para Mine	Shropshire Union Canal, Parkgate Road	1 casualty	30 houses damaged, canal bank damaged, telephone wires cut.
Total	3 Para Mines 44 H.E. 344 Incendiaries		3 Killed 15 Casualties	
Alerts	232			
Duration	383 hours 22 min			

Dorothy Thomas (later Dorothy Jones) described life in Chester through the eyes of a ten-year-old as she was in 1939:

Just prior to the Second World War I was living with my family; my mother, father, elder brother, John, and younger sister, Mary. We lived in Newton, which is on the outskirts of Chester. My parents had opened a cake shop in town and worked very long hours, especially with the baking. Before the war and rationing, they sold all types of luxurious cakes, buns, pastries, pies, birthday and wedding cakes. One day in August 1939, my mother heard from a relative in London that air raid shelters were being prepared. It was a sign of things to come. On Sunday 3 September 1939, it was announced on the radio that we were at war with Germany. I went out into the back garden and looked up at the sky expecting bombs to be dropped. Nothing happened for some time. It was to be my tenth birthday on 3 October. At our local school we were preparing for bomb attacks and had to have air raid shelter drill, usually daily. We were issued with gas masks, and were told to carry them around with us at all times. Not to do so ended with a caning from a very strict headmaster. Some of us had the job of sticking tape to the windows, to protect from splintered glass.

Then later, the war started in earnest. No longer was it called 'The Phoney War'. Ration books were issued and we had to register at a grocer and a butcher. Sweets were rationed to 12 ozs a

month. I had used up mine in a few days. Clothing and petrol were rationed. We were told to use no more than three inches of bath water. Rationing started with minimal amounts of butter, sugar and flour. I remember we were allowed one egg a month each. Of course, people on farms fared better. Men were called up or volunteered. Women now had a big role to play in running the country. Women worked all hours in munition factories and hospitals. They also drove ambulances, ran canteens and did all jobs previously done by men. We had posters everywhere telling us to not waste food. Men gave their lives to bring it to us. Many hundreds of merchant Navy ships were sunk and so many brave men lost their lives. My father joined the Navy and now the cake shop could only open two and a half days a week; that was all rations would allow. My mother was kept busy with a home and business to run and only one woman to help her. The blackout had been introduced and air raid wardens were very strict. Many thousands of people were killed on the roads because of very poor visibility. Place names were covered on stations so as to avoid helping the enemy. Any small amount of black out curtain not covering the window was soon pointed out by an air raid warden. School dinners were introduced because so many mothers were on war work. It was safer, as children didn't need to go home for a meal. I know they did their best but sometimes the food was awful. One really needed to be hungry!

Chester is situated only miles from the Ports of Liverpool and Birkenhead. They were targeted by bombers of course, for heavy and continual bombing from German bombing. We visited Liverpool many times. The bomb damage was very sad to see. Almost derelict shops had a notice hung on a door 'Business as usual'. Of course, many other cities were destroyed and thousands of lives lost over more than six years of war. Sometimes at night we would look out from our front room window and see the sky alight from the many incendiary bombs. The bombers pounded Liverpool and Birkenhead for weeks at a time, but we never gave in. We hit back. People helped each other so much in those dreadful times. When bombs were dropped on Chester, we used to get our bikes out and go to collect 'shrapnel'. We didn't get a lot of bombs on Chester; mostly the bombs were for military targets and ports.

Life got pretty hard at times for all of us, so we were glad of a break. We had relatives in Llandudno, a beautiful seaside resort in North Wales. During summer school holidays, my sister and I would take a train to visit them. We would just leave a note for Mother, who was busy in the shop, to tell her that we were going there. My Auntie Edie (my mothers' sister) and Uncle Alex (fathers' brother) were very kind to us. They put up with us for weeks. Whilst we were visiting, the so called 'black bread' was introduced. Mary and I were happy to have this big change in bread, but not for long. A funny side to this story was the night Grandma, who lived with Auntie and Uncle, boiled their few eggs and used up their entire tea ration. They had just popped next door and Grandma heard Paul Robeson singing on the radio. He was her heart throb so she made many cups of tea and boiled their only three eggs all around the radio! She also drew back the curtains, to get a view of the sea. The air raid warden was round quick sharp! We spent some happy days visiting Happy Valley, situated within the Great Orme there. As we spent most of our money early in the holiday, we could sit on the hill and watch the entertainment free, as it was an outdoor show. Alex Munro was the 'leading light' there and cheered us up immensely.

On arriving home with heavy hearts, brother John suggested making an air raid shelter in the back yard. We dug quite a large hole and put many of our beloved trinkets into it. Later in the week we had very heavy rain and the whole thing collapsed luckily no one

FOOD FACTS

NEW ways of using dried eggs

They'll help you to give variety to your cooking

Not everyone realizes the large number of ways in which dried eggs can be used. Here are some suggestions for using them in ways which will be new to many women.

Pastry looks better, tastes better, if you brush it over with a little reconstituted egg before baking.

It's quite easy to make hard-boiled eggs with dried eggs if you follow the instructions here.

To save fat in frying: Use reconstituted eggs for coating fish fillets, fish cakes, rissoles, bread, sliced cooked potato, before frying. You need less fat this way, as the egg forms a coating which stops the fat being absorbed.

A "fresh-flavour" tip for Scrambled Eggs: Have you tried adding a little mustard when making scrambled eggs? Add it with the other seasoning — half a teaspoonful of dry mustard for four eggs.

Hard boiled eggs: Reconstitute the eggs in the usual way, and pour into well-greased egg-cups or moulds — one egg to a mould. Put the moulds into a saucepan of hot water coming half-way up sides of moulds, and simmer gently for 15 minutes, until set. Turn out by running a knife round the edge.

French Fry: Dip pieces of bread in well-seasoned reconstituted egg, soak well, and fry with bacon. This is more nourishing than fried bread and uses less fat.

THE PRESENT ALLOCATION of dried eggs is one packet per ration book each four-week period (as from April 29th), two for green books.

More children to get orange juice in May and June

Good news! Thanks to a temporary increase in supplies, the allocation of orange juice will be extended to include children from 5 to 10 years old, for eight weeks between May 7th and June 30th. If you are the mother of a child under 10, don't miss this chance of giving your child this valuable food, rich in Vitamin C. A bottle of orange juice costs 5d. Take your ration book and 5d. in stamps to your nearest distribution centre or Food Office.

LISTEN TO THE KITCHEN FRONT ON TUESDAY, WEDNESDAY, THURSDAY & FRIDAY at 8.15 a.m.

ISSUED BY THE MINISTRY OF FOOD, LONDON, W.1. FOOD FACTS No. 253

Alternative recipe advice in time of shortage from the Ministry of Food was frequently printed in the pages of the local press.

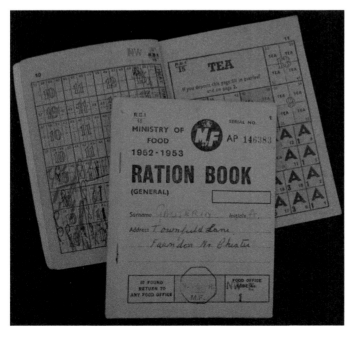

Ration book. (Lewis Royden)

was in it! I suppose that buried treasure is still there. We also acquired a greenhouse. We grew tomatoes, which required lots and lots of watering. We also bought some hens and a cockerel which meant we now had some fresh eggs. On the rare occasion my Mother served us roast chicken for Sunday lunch, my sister and I used to run down the garden to check which of our hens was missing. Should it be Patsy, Charlotte or Polly, there was no way we would eat it, no matter how hungry we were! One day I thought I would try and hatch out an egg. I put a candle underneath an egg and swathed it in straw and waited and waited. Later smoke was billowing out of the green house. I don't think we kept hens after that...

As a means of protection from enemy aircraft, large silver barrage balloons were used in the sky. The Battle of Britain was a turning point in the war. Brave young men, some with only hours flying experience were sent up to fight enemy aircraft. Thank god for the Spitfire. On the edge of pavements, emergency water pipes were fitted (or E.W.S. as they were known). They had a translucent paint on them, because of the black out. I vividly remember some American soldiers who tripped over them and they used some choice language. There were servicemen from all over the world, based in various camps. We had Americans, Canadians, Australians, New Zealanders as well as Poles. Quite a number of British girls got married to these servicemen and went back later to their individual countries.

Evacuee children were brought to Chester from Liverpool and Birkenhead. The bombing got so very bad at times in their home towns so it was for their own safety that the children were moved to Cheshire. I pitied them at our school because the headmaster was extra strict with them. The government also brought out a scheme to send children to the Commonwealth countries. Unfortunately, many children were drowned when their ship was sunk. The scheme was then cancelled. Our morale became rather low at times, understandably. To cheer us up, comedy programmes hit the airwaves. I well remember one in particular, It was called *I.T.M.A.* short for *'It's That Man Again'*, the man being Tommy Handley. The British sense of humour has always been excellent.

My brother John was anxious to get into the war 'before it was over' as he said. He eventually did and became a navigational officer in the merchant navy. He, like many others, went off to war as an eager young man but came home much wiser.

Eventually, VE day arrived. There was much celebrating, my mother and I were in the Town Hall Chester that evening. Mum would have liked a celebration drink and we attempted to get one for her from the bar but the crowd was so large that we got swept right round past the bar and out again. Ah well, such is life! I was now sixteen and we were to have many more years of rationing. America and Britain had agreed on a lend lease arrangement. This helped a great deal; however, it took many years to repay. Servicemen arrived home to unemployment, a country mostly suffering bomb damage and almost bankruptcy. So many plans for rebuilding, such as our very old school, had to be put on hold for many years. But for a small island Britain achieved a great deal during the war and I am, and always have been, very proud of this.

Dorothy Jones (née Thomas), *BBC WWII People's War*, 11 January 2004

Noreen Sargent was a little older and had already started work for a local company:

I was 17 going on 18 and living in Chester when the war started, and had just finished a secretarial course at college. I went to work at Brookhurst Switchgear. It was a Sunday when

Mum and Dad heard Chamberlain's broadcast and I remember them looking extremely worried as they had memories of the First World War. During the first weeks we busied ourselves making curtains for the blackout. My two elder sisters joined the ARP and my two brothers were still at school. I joined the Red Cross as a VAD, so we had one night a week of lectures and then I was able to work in the local infirmary on a Sunday. It was really hard work compared to today, we had to actually wash the bandages and deal with bedpans.

We had no bombing in Chester but the planes went over for the bombing of Liverpool and once they offloaded a landmine on their way back to Germany. Very noisy but luckily no damage. We did various fund-raising activities for the Red Cross, one of which was an auction at the local cinema, where someone paid ten shillings for a banana. I had to take it to him and I was very jealous as I could easily have eaten it myself. New clothes were a rare treat and we were always altering and adapting our existing wardrobe. We had to sew everything by hand and my sisters used to laugh at the state of my room, which was full of things having been hacked to pieces in readiness for some wonderful new creation. Our local chemist used to make up tinted calamine lotion, which doubled as liquid stockings and face make-up.

Chester was a garrison town and full of troops. There were dances all over town and we girls had a wonderful social life. We also had an army doctor and a captain in the engineers billeted with us. We didn't have to share our rations with them they just lodged with us. My mother had a hard time feeding a family of seven on the rations allowed. We grew all our own vegetables and my mother used to bottle fruit, salt beans and preserve eggs in glass water. After Dunkirk we had a lot of wounded in the infirmary and we also had a hostel just around the corner where the families of the wounded could stay when visiting them. We used to go and serve them meals and put a hot water bottle in their bed. We were lucky as a family as we lost no one close and survived relatively unscathed.

Noreen Sargent, *BBC WWII People's War*, 10 May 2005

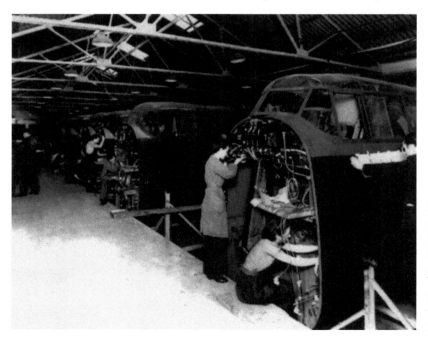

Installing control panels in Wellington Bombers at Anchor Motor Works after their assembly at the Broughton Factory.

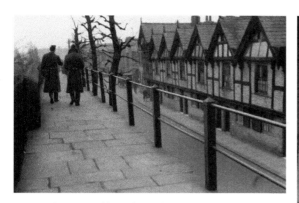

Above: Strolling along the city walls, 1944.

Right: Chester railway station, 1944.

RAF Sealand had already been established at Queensferry in 1933 as a flying training school, and was well placed to support front-line squadrons once hostilities commenced by repairing engines, instruments, armaments and wireless telegraphy equipment. By 1938, two large aircraft factories had been established: Vickers-Armstrong near Hawarden and de Havilland at Broughton – both would go some way to provide much-needed local employment.

Either side of the Dee at Queensferry, RAF Sealand and RAF Hawarden were also operational during wartime, both as pilot training bases. RAF Sealand came under attack on 14 August 1940, when a lone Heinkel He111 made a surprise raid, dropping one incendiary and eight high-explosive bombs across the airfield and camp. The main electricity cable was severed, the roof blown off part of the sergeants' mess, and damage caused to the main guardroom and airmen's block. A warrant officer was killed, and twenty-five airmen were injured in the attack, while the last bomb killed a horse grazing in an adjacent field. Once it had unloaded its bombs, the Heinkel attacked again, this time machine gunning parked aircraft, damaging eight Masters and three Oxfords. Three Spitfires were scrambled from 57 OTU at Hawarden and managed to force the Heinkel into a crash-landing in a field about 20 metres from Border House Farm in Bumpers Lane, Chester, where the crew set fire to the aircraft before being captured by the Home Guard.

Hawarden Airfield had been established on 1 September 1939 and became one of the main RAF airfields during the Battle of Britain. As well as being a training ground flying Spitfires and Hurricanes, Hawarden played a major role during the war supporting maintenance, transport and construction. The factory at Broughton was established early in the war as a shadow factory for Vickers-Armstrong Ltd, and by 1945 had produced 5,540 Vickers Wellingtons and 235 Avro Lancasters. (PA474 is one of only two Lancaster aircraft remaining in airworthy condition out of the 7,377 that were built, and was completed at Hawarden on 31 May 1945, later becoming part of 'Tiger Force' against the Japanese. PA474 is now part of the RAF's Battle of Britain Memorial Flight.) After the war, the Vickers factory built 28,000 aluminium prefab bungalows for those who had lost their homes during the Blitz.

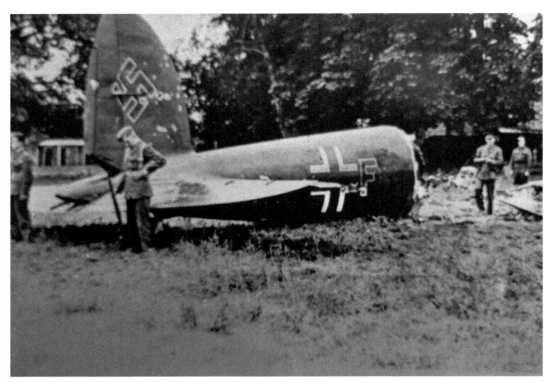

Above and below: Remains of the Heinkel 111 in a field near Bumpers Lane, Chester, shot down after being engaged by three Spitfires from RAF Hawarden, 14 August 1940.

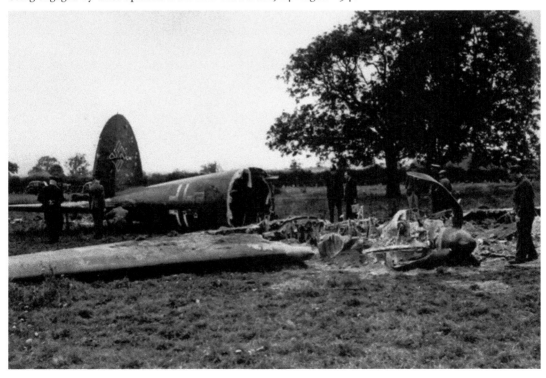

Chapter 8

Western Command

Nora Gauterin (née Gopsill) was only twenty when she began her life underground in Chester. Born and raised in Birkenhead, she worked as a typist in Old Hall Street, Liverpool, for John Moores, in his growing Littlewoods Mail Order empire. She was still there when the war started, and while her younger brothers were evacuated to Western Rhyn in north Shropshire, Nora stayed home helping her mother care for her aging grandmother. She and her family had already endured the horrors of the Blitz before she signed on for war work as a typist at RAF Hooton. A few months later, Nora was called up, and she was despatched to Harrogate to train as a teleprinter operator with the Royal Signals.

Nora Gauterin (who was just a few months away from her 100th birthday at the time of writing) recalled,

> The course was very intensive and when we were not actually learning our teleprinter technique, we were learning a great many code signals with which we had to be perfectly conversant. Electricity and Magnetism was extremely uninteresting to me, and we used to have screeds of notes and homework to do on this subject. For relaxation (!) we had lots of route marches over the moors. As we were in Queensbury towards winter time – it always seemed to be cold and wet and the terrain most uninteresting. Queensbury, we were told, was the highest village in England. I could well believe it, for it was the coldest spot on earth to me, and I hated every minute of my time there.

After three months and gaining a pass in her final tests, Nora served in a couple of short posts in Newcastle and Leeds, following which she was then able to secure a transfer to Chester to be closer to her mother, who was in ill health. Just a few weeks earlier, Nora had suffered great personal tragedy, where during a period of home leave, she lost her fiancée to tuberculosis, a scourge without cure, which killed thousands throughout the war.

Lance-Corporal Nora Gopsill, signaller, Royal Corps of Signals.

Life goes on of course, it has to, and there was no time to stop and feel sorry for yourself. Everyone had lost someone – everyone had a heartache to hide – and in the meantime the war went on. About this time my mother became ill too – her nerves just got the better of her, and she had a breakdown. However, our doctor thought I would do better to be nearer home in case mother did not return to full health and I was needed again. So, he wrote to my C.O. and the upshot of all this was that I was given a compassionate posting to Chester – Western Command.

Well, that was alright I thought, though I had hoped to see more of the world as it were. I had volunteered to go overseas, but all those plans had to go now. So, I told my best friend Phyl about my posting and we were very sad really, for we were to be separated now. A very subdued me started to pack my things ready for the move, and a very thoughtful Phyl who mooched around for a few days. Then – out of the blue – a posting came for her too. Guess where? Western Command of course. The sly puss had sung such a sob story about her mother being ill, had twisted her family doctor's arm for a letter, and lo and behold – we were to be together once more. Just in all fairness, Mrs. Hayes was a sick woman indeed. She had a very bad heart condition, but Phyl had never dreamt of playing on that until I was to leave – then she swung into action. What a hoot – we fell about together – but never did two more sombre ATS girls get on a train before, since we were both being posted nearer to our sick mothers. Heartless pair that we were, we rocked with laughter once we were on our way. Not at all unhappy to leave our dreadful digs I can assure you, and looking forward very much to our next adventure in Chester.

Western Command was established in 1905, and was originally called the Welsh & Midland Command before changing its name in 1906. In 1907, Western Command relocated to Watergate House in Chester, where it also oversaw operations during the First World War. Facilities were increasingly inadequate, however, and in 1938, after a brief stay in temporary accommodation at Boughton, it moved to a new purpose-built neo-Georgian property known as Capital House at Queen's Park in Chester on an elevated site overlooking the River Dee. Bunkers containing offices, plumbing

Right: The recently opened Western Command viewed from across the River Dee.

Below: The same building today, with additional classical features, now occupied by the University of Chester. (Lewis Royden)

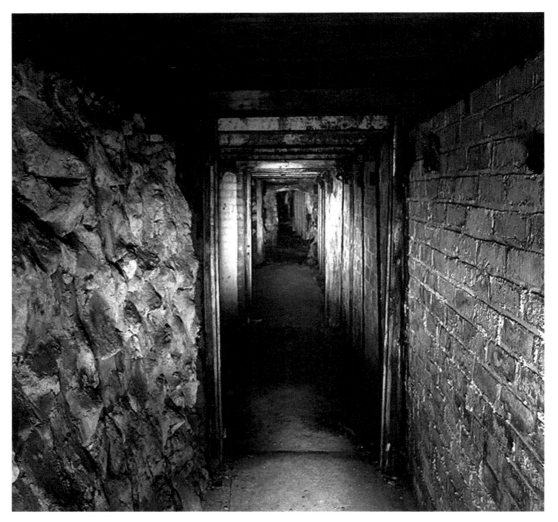

Corridor in the underground bunker below the Western Command building. (www.28dayslater.co.uk)

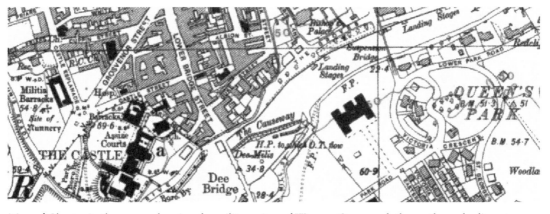

Map of Chester in the 1940s showing the military sites of Western Command, the castle, and adjacent military buildings.

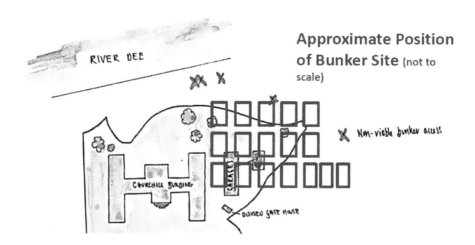

Approximate Position of Bunker Site (not to scale)

RIVER DEE

✗ Non-viable bunker access

CHURCHILL BUILDING

CREAKES

DISUSED GATE HOUSE

Ground plan showing an approximation of the underground bunker. (Chantal Bradburn, University of Chester)

systems, air conditioning and operational facilities were constructed in the vast underground space in case the building above was destroyed by bombing. In 1941, it was camouflaged, a dark grey wash being applied over the new bricks and stonework to help prevent it being seen from the air. The geographical area controlled by Western Command stretched from Hadrian's Wall on the Scottish border to Tewkesbury in Gloucestershire, and included Lancashire, Cheshire, Wales and the West Midlands, and from 1907 to 1972 the garrison city of Chester was its headquarters.

After the usual long and boring journey we eventually reached Chester station, and laden with our kit bags etc. we found our way to the College in Parkgate Road. A dark and rather dreary looking building, not at all inviting. Many steps led to a big oak door and we struggled up them reporting for duty at the Orderly Room. [Now the main campus buildings of The University of Chester. The new building on the Queens Park site of the Western Command building is also part of the University].

A laconic sergeant of huge proportions greeted us and summoned a passing private to show us to our quarters. This turned out to be a room housing eight double bunks home to sixteen girls. A big cold room and the ablutions were in a further icy room across the passage. No hot water of course. Once there, we thankfully dumped our luggage and said we'd make up our bunks if we could have some bedding. No bedding. We were given a couple of blankets each and a pillow without a pillow case. Not too clean, but that's all there was. Made up our beds and then went back to the Orderly Office to see what we were to do next, the large sergeant said that Commander Jackson (our CO) would see us in the

morning and in the meantime, we would be shown the dining room, have a meal, then settle in for the rest of the day. This we did and made the acquaintance of our roommates, who turned out to be a mixed bunch, but not a bad lot of girls. By then it was getting towards evening and we were tired, so not being allowed out just then, we decided to turn in.

Next morning, after breakfast, we presented ourselves for the interview with Commander Jackson, looking as smart as we could (and we had quite a reputation for being very smart had Phyl and I). If we hoped to make an impression on our new CO we had another thing coming. Commander Jackson was a small woman, obviously very efficient, who expected her girls to look smart – so no comment on our appearance. She told us that she demanded exemplary behaviour from her ATS or else, and told us that applied to our work also – this latter being most important. We were to be put on 'A' relief and our first day was a 1–8 p.m. shift. We could either walk to Western Command (2 miles) or wait to go on the lorry with the rest of the girls. She advised (commanded!) the latter course as then we would be shown the ropes and meet the sergeant in charge of our relief. So, we then were dismissed and went off in search of bedding etc. and to explore a little. This took us up to lunch time and we returned to the dining room, which was a lovely old room – a refractory and it was beautifully panelled and domed. Huge long tables and benches – parquet floor etc. but we never appreciated all that then, and the food was indifferent to say the least.

Time then for the lorry, and off to Western Command. An imposing building by the River Dee, and the Signals Offices were way down in the catacombs, in the depths. Very long dark passages, some not very well lit – and here were housed the teleprinters, switchboards and all the signal offices, including the Despatch Riders office, which accepted and sent out all sorts of parcels and letters and despatches. It was a far bigger Signal Office than the offices in Leeds – well this after all, was the Headquarters of Western Command.

So it was our first experience of in a bigger place and it was very exciting. We were shown to our teleprinters and procedure explained to us and off we went on our first duty in Western Command. I found it enthralling and I certainly felt that at last I was taking part in a big operation, and in the war effort itself. The whole ghastly business of war became real to me then. Until then, despite having been through bombing raids, air shelters, rationing and what have you – it had all seemed rather remote in a way – a macabre game we were playing, but suddenly, it was very, very, real and the receiving and sending of signals appertaining to even the mundane things of war, i.e. the sending of supplies etc. was very meaningful to me, and I was so proud of being able to do my bit. It was confusing at first though, but we rapidly got used to it and before too long we were sending and receiving messages quite well. Obviously, as beginners we had a lot more to learn, but we knew we would soon be as proficient as our colleagues – we had to be, no doubt of that, or else we would have been on our way elsewhere, after having been well and truly hauled over the coals first.

Then began the pattern of shift work – route marches (when we were off duty), cleaning our barrack room, and doing our buttons. The cleaning of rooms was frustrating since we never had hot water, and cleaning materials were not issued, so we had to make the best of things and usually, we had to re-do it to the sergeant's satisfaction. Button cleaning, and pressing of uniforms was a MUST and we (Phyl and I that is) always took pride in looking our very best, so we never minded that chore, but route marches were just awful. There were

not many places one could route march around Chester. However, we did devise a scheme whereby we contrived always to be at the very back of the line and on would march the others, with N.C.O. alongside, and Phyl and I would march slower and slower until we could just hive off into the nearest bushes or down a side street and so back to base. We took awful chances I realise now, and it certainly wasn't fair to the others who had to do it, but at the time it was all a big giggle and what was more, we got away with it. If ever we had been caught – heaven help us.

As well as these things, it was decreed that we now had to learn the Morse code. I found that this was something that did NOT come easily to me and I had to work long and hard at it. However, I did pass the exam, thanks to the determination of my shift sergeant who made me stick at it and who made very sure that I did not shirk any practising of same. I must add that I hated Morse so much that I promptly forgot it when it was no longer needed. My mind seemed to reject it utterly. Strange.

As well as the fascinating insight Nora gives of life in the bunker, she and Phyl also had a life above ground, and when time would allow, they would live it to the full, as others did, trying to forget for just a few hours the reality of war.

But if we worked hard (and we did) then we certainly played hard. There were, at that time, thousands of troops of all nationalities around Chester. Americans, Free French, Polish, Czech, and of course our British soldiers, airmen etc. We received lots of invitations to

Certainly quaint in comparison to the legendary rock nights of the '60s and '70s (many attended by this author!), Quaintways was just as popular in wartime Chester.

NAAFI Club, Love Lane, Chester.

dances, and of course, it follows, that we all had lots of boyfriends and were out socialising at every opportunity. To me this was freedom at last, living it all up with a will. No strict eye upon me and no one to say what I could or could not do. I think I went a bit wild, but hasten to add – not in any immoral sense. My very stern mother would have known instinctively, and I could never have faced her gimlet eyes knowing I had flouted her well instilled doctrines. But I had lots of dates, and was out dancing as often as was possible. There was a big NAAFI club in Love Street, Chester, and there were a couple of dance floors there and a self-service cafe as well as a 'posher' type of cafe. We haunted that place and were usually to be found at the afternoon dances as well as the evening ones. The other place to go to was the Riverpark Ballroom by the park, rather a glorious and grand name for what was quite an ordinary sort of dance-hall. But we could get in there for 3*d*. (1½ p) being in uniform, and a lot of our despatch riders used to frequent it, so we were always sure of someone to buy us a cup of tea in the interval.

[Riverpark Ballroom was then known as the Broadway Dancing Academy Ballroom, nicknamed 'The Ack'. In the early 1960s, The Beatles played this venue several times, including the evening on the day John Lennon married Cynthia, and on the day Pete Best had been sacked, his place filled for that gig on 16 Aug 1962 by Johnny Hutchinson, drummer for The Big Three. It was later demolished and a bank built on the site.]

It was here that I met Sam McCracken, an American top-sergeant. He was a giant of a man, very good looking and very gentle with a soft voice. He came from Cairnstown,

The Plane Tree, Bridge Street.

Above: The River Park Ballroom, Chester, in the 1960s.

Left: The 'Ack' Ballroom to the rear of the River Park building.

Pennsylvania, and was very nice to know. We met as often as was possible, since we were both on shift work. But when we did meet, he always brought me sweets or tins of food, peanuts or fruit. I kept most of these to take home of course, and they were a very welcome addition to mother's rations and young Jim loved the peanuts and chewing gum. Sam always used to take me to the PX the American equivalent of our

NAAFI. There he would feed me enormous meals – turkey, steak, and more, because he thought I never got enough to eat. This was because I was still very thin and frail looking, so he was deceived really, for I could eat anything by now, and still not put on weight. But I did so enjoy those meals, and Sam used to sit and look at me and wonder where I put it all.

Inevitably, Sam had to leave Chester, and we had a last embarrassing and painful meeting. You see, we were aware that something BIG was about to happen – all leave had been cancelled, no passes at all had been issued, we were on curfew, not allowed out of Chester on any pretext and were working full out. Anyway, Sam and I arranged to meet and walked to the Groves by the river. It was here that he broke down and actually cried, saying he didn't want to fight any war, he didn't want to go anywhere. I was horrified and with utter astonishment and great callousness I berated him for his tears and his protestations that it was not America's war etc. I turned and left him sitting on a bench by himself. I was so cruel and cold then, I couldn't put myself into anyone else's shoes and understand how they could feel, so dismissive and scornful was I. But I have many times regretted that action and wondered about him. I hope he got back home safely – he deserved to and I needed a sound chastening for my attitude to him. Poor Sam – I will never know what happened to him, and I never had another American boyfriend after that.

Tension grew the while and we were all tensed up at work too, wondering what was going to happen. By then, I had gained one pitiful little stripe. I should have had more – I knew that, but I did disobey an order! Unheard of in 4th Command Signals, but I did it and I never regretted it. It was when we were on a night duty that our relief officer told me I had to take charge of the shift and the signal office, as she was taking our sergeant to a party. This seemed to me quite wrong and I protested, saying I didn't think I should do that as I did not have enough experience to take the responsibility for the whole of the signal office. She was furious, absolutely, but she couldn't really charge me as she knew she was in the wrong. However, she made sure that I knew she would never let me be promoted if there was any way she could stop me but I didn't believe that she would do such a thing. She did though. Whenever I was in line for more stripes, somehow, I was always passed by, and it was tacitly understood that 'ma'am' had it in for me.

However, I was put in charge of the Despatch Office – even a lance-corporal could do that job it seemed. But I liked it there very much. The despatch riders ('don r's' we used to call them) were a great bunch of lads who joked with us, teased us, shouted at us, but looked after us well. There were four of us in the Despatch Office and we were a good team, but suddenly one day, I was told to report back to Teleprinters. I did so greatly puzzled, and rather annoyed by this sudden move. So, there was I once more sending and receiving messages, but as I quite liked teleprinting, it was alright, but I missed the camaraderie of the Despatch Office. There was still this ever-increasing awareness of something pending, and to my astonishment I was put on to sending and receiving cipher messages. This was top secret, and of the utmost importance, so I was locked away in a little room where there was just a teleprinter, a chair, and me, and this is where I spent most of my time teleprinting code messages and receiving them. It was tedious and tiring but I did recognise the tremendous importance of it all.

The year was now 1944, and what Nora had sensed was the build-up to one of the most decisive phases of the Second World War. Montgomery was reported to have attended meetings at Western Command, and if the rumours that Churchill, De Gaulle and Eisenhower did meet in secret there too, it would have been in the build-up to the events of June 1944. (In 1943 and 1944, secret meetings were reputedly held in the underground bunkers between the three leaders, but reliable evidence of this has been difficult to discover, and seems reliant on local hearsay. Nora never heard any talk, rumour or otherwise, of this happening at all during her time there; 'We used to see a lot of officers, a lot of Red Caps, a lot of brass and big cars coming and going but we were just there to collect messages, send messages and that was our job.')

Came June 6th 1944 and it was THE DAY – D-Day – and the invasion was ON. This is what it had all been about, and there was an air of suppressed excitement and anxiety all around. We gained little knowledge from teleprinter coded messages, but off duty we listened avidly to the radio and devoured all the newspapers. Some lists of dead came through the teleprinters, men who came from the area around Western Command. Tragically, a few names were those of people I knew, boys I had gone to school with, grown up with, neighbours. We all seemed to know someone, and we all yearned to know that those lives had not been given in vain. The war went on, the invasion went on – at what a cost. We learnt that it was successful and slowly, oh so slowly, the news filtered back to us about how our armies were faring, and how they were progressing. Dunkirk had been a catastrophe, but we had been supremely lucky in that the Germans did not follow our routed troops back over the Channel to England. D-Day had to be successful at no matter what cost – and Thank God it was.

The horrors of the German occupation of Europe soon became clear to us. We used to have to attend lectures each week the Army Bureau of Current Affairs (ABCA). These lectures told us what was going on in the war and many, to our shame, found them rather boring. It may have been the lecturers, or our own stupidity, but no, – these lectures were not only interesting but compelling. We were shown films of the concentration camps that our Armies had discovered. Dreadful beyond belief, and we had to watch them. How can one describe the full horror of those camps – the mounds of dead bodies, the gas ovens, the skeletal figures tottering around. These films and the stories that were told were sickening, terrifying and almost beyond comprehension. The glorious Third Reich and its infamous leaders were responsible for the deaths of over 6 million Jews – to say nothing of the millions of other people in occupied countries who had suffered unbelievably under this reign of terror. I remember how girls fainted when they saw the films, and I personally felt that I could never again think kindly of a German. In due course, the films were shown in cinemas throughout the UK, and people were told that they HAD to go and see them to see for themselves the evil we had been fighting, why those young lives had been given. I would defy anyone to watch those films and read those accounts of what was discovered, unmoved and without anger. Certainly, I personally felt ashamed that the war – to me – had been pretty good. In the light of what others had suffered, I had been so very lucky, that is why I always remember November 11th – Armistice Day – when we think of ALL who

sacrificed so much for us. Not just the Forces dead – but those who died so horribly in those camps, who gave their lives in resistance movements and those who just vanished, never to lie heard of again.

The intensity of the build-up to D-Day now relaxed and there seemed to be much less tension both above and below ground for Lance Corporal Gopsill as the final months of the war approached.

During this time, very slowly, but very surely, we went back to our old routine. The pressure was off and life was more normal. We resumed our mad whirl of work and play and sleep. Now when we did our night duties, we did not seem to be as busy and often we were allowed to go and lie down for an hour or two. We used an old NAAFI hut which had some straw mattresses in it. Not too comfortable I grant you, but bliss to us, since most of us went straight on to night shift at 8 p.m. after an afternoon of shopping, walking, dancing or coming straight from home (which was what I did when chances allowed). On the odd occasion, say at weekends, when not too much was happening, two girls would be sent back to the College and so to their own beds. A call was put through to the orderly room and the two girls made their own way back, reported in and went to bed.

One night, mid-winter, very cold and extremely dark, Phyl and I were sent off duty. Away we went clutching at each other for reassurance and safety, with one small, rather dim torch to light our way. Out of Western Command, and over the suspension bridge, then up the steps by St. John's church and then hot foot through the deserted town to the College. We were just going up St. John's Church steps when our torch lit on two enormous feet. Gasp – oh horror – we were stiff with fear, couldn't move. Our torch travelled up to … a big policeman. Oh, the relief, even when he scathingly asked just what did we think we were doing, and just where we were going. We hastily explained and, glory be, he believed us, and even saw us through to the main road with many exhortations to 'watch it', 'be careful', and 'don't know that they (the Army) are playing at' etc. And did we leg it back to base. Though it was a bitterly cold night, we were sweating when we breathlessly reported in.

During this time, Phyl and I, still hating the food we were given at the College, often had a meal at the British Restaurant. These eating places were set up in most towns and provided a good basic meal of whatever was available for about 1/6d (8p). You could get corned beef fritters, fried egg omelette, rissoles of doubtful ingredients, always with chips of course, bread and butter (margarine) and tea. Not bad for what we paid, though we couldn't afford to do it too often. Sometimes we made do with a toasted bun and a cup of tea at the Toc H which was super, and sometimes we made our way down to Linenhall Street where the Salvation Army had a canteen. There we could buy toast and tea, and sometimes get a small bar of chocolate, without coupons which was great. Other times we frequented the English Speaking Club in Watergate Street, and if we hadn't much money, we just had cheese and onion on toast.

[In 1915 army chaplain the Reverend Phillip Byard (Tubby) Clayton was serving in the town of Poperinge in Belgium where he was instructed by his senior chaplain, Neville Talbot, to set up some sort of rest house for the troops. He set up Talbot House in honour of Gilbert Talbot (Neville's brother) who had been killed earlier

in the year. Soldiers nicknamed it Toc H, signallers parlance for the initials TH. Like most organisations, many of Toc H's members were called to fight in 1939. Those who were left (along with the League of Women Helpers), turned their attentions to helping the war effort by starting Service Men's Clubs both at home and abroad in the theatre of war. For many future members this would be the way they came to Toc H.]

On our perambulations around Chester, we often saw a slim, dark, tall young man. He was very good looking and walked with such assurance. I felt sure he had a large opinion of himself and said so in no uncertain terms, much to Phyl's amusement. We used to see him, usually with a girl, in the British Restaurant, and I would glare at him, not that he took the slightest bit of notice of me. Why should he – he was so handsome – I was nothing to write home about, but I wondered – oh yes, I wondered.

Then one day Joan Connor, one of my pals – a super girl with a tremendous sense of humour and a passion for music (she was a very good pianist), put an idea into our minds that we should give a concert. I don't think Joan ever realised she was responsible for this, but she and I used to act the fool and dance and sing for our chums and everyone had a good laugh. [It was at this time that Nora also used to sing in a small concert party and met comedians Arthur Haynes and Charlie Chester.]

Anyway, the whole thing grew and before we knew where we were – we were getting a concert together. It was hard work, enormous fun, and a huge success. From this we decided that we would then save up to have a Christmas dinner at the Plane Tree restaurant. So, each week we all put something in the kitty and in no time at all, we seemed to get quite a lot of money. There were about twenty-five of us on our shift, and we decided it might be a nice idea to ask twenty-five of the wounded soldiers from the Dale Reception Centre (now Dale Army Camp, Upton, to the north of the city) to join us in this Christmas festivity. So, we duly sent out the invitations and informed the Plane Tree manager what we intended to do, and he said his staff would help as much as possible. Day of the party dawned and in the evening, we all gathered at the restaurant to await the arrival of our twenty-five guests. They duly arrived, poor lads. Some of them were on crutches, some had lost a limb, one had lost an eye and a hand; but all of them ready and willing to enjoy the fun with us. The staff of the Plane Tree had done us proud. They had also had a whip round and all the boys were presented with a bottle of beer, a small gift (hankies, cigs, shaving stuff etc.) and a small cigar. The whole thing went off tremendously well, and the best after dinner speech I have ever heard was given by our relief sergeant. When called upon to speak, she just stood up and said 'Ladies and gentlemen, I am too full for words' and sat down. Great – full of food and full of emotion – quite the best speech ever.

Joan at this time was going out with a very tall, quiet looking, but very attractive soldier, and she said she was going to get married. We were so pleased for her and a little while later, when we were planning to have our de-mob party she said she would bring her Ron and his cousin to the party. She seemed to think I would get on well with the cousin, as he had the same sort of silly sense of humour that I had! Very flattering. Came the night of the party and I was feeling awful with a cold, my mouth had cold sores round it and my skirt was all frayed at the bottom (couldn't have a new one as I was due for OUT in a day or two). In came Joan with her Ron, and – the dark handsome chap I couldn't stand! She introduced us and we danced. Well, he couldn't dance for toffee believe me, but I found him

very attractive and before that night was out, I knew that in Glynn I had met the one who really mattered. He told me, much, much later in life, that he had felt the same!

So much has happened since that fateful meeting – Phyl married her Tom who came back after six years abroad, Joan married her Ron (Glynn was the best man, but I was ill and couldn't attend that wedding). I was demobbed however, after our CO had almost pleaded with me to stay in the Army and go on an officer's course, but I had met Glynn, I knew we would marry, so out I came.

I was whipped into hospital with peritonitis soon after I was demobbed (though I had my job in Littlewoods back again) and Glynn and his brother George travelled up to Birkenhead to see me through the most dreadful weather. It was one of the worst winters we had ever known, but still Glynn came to me. My mother, by then, had not a lot of time for me, she had had such a bad time, what with Granny and her only sister recently dying – I'm sure she had had enough of illness and such. So, I was so grateful for Glynn and his family. I do have to record though, that when I was due to leave hospital, mother said I had to come home alone, and she would not call a taxi for me. I walked to the nearest bus stop in the snow, carrying my suitcase, and arrived home almost in a state of collapse. My mother was hard though, and I just had to get on with it, but I went down then with septic tonsils and was in a pitiful state when next Glynn saw me. That was when I saw him assert himself as he very rarely did. He just wrapped me in the car rug and – much to my mother's astonishment – took me home to Churton where his mother cared for me until I was better. They were all so very kind, I'd never known such kindness. Certainly, I could never repay them, and I learnt so much from Glynn's mother who was the sweetest person imaginable.

CHURTON VILLAGE, NEAR FARNDON.

"The Unique Series".

Churton Village, home of Nora's future husband Glynn, and the start of a new life.

My greatest compliment ever, came when she introduced me to a doctor saying 'this is my daughter-in-law, but she is much more like a daughter to me'.

In due course, Glynn and I were married in Aldford Church, June 1947, and later we had two sons Peter and David. Glynn was, without doubt, the kindest, most patient man I have ever known, he spoke ill of no one and to know him was to love him. We had had thirty-four years together when he died on 6 January 1982 of heart failure. To me he is irreplaceable.

At the time of publication, Nora was still living at home in Great Boughton, still fiercely independent and just a few months off her 100th birthday.

Chapter 9

VE Day, Chester

When the news of the end of the war came on 7 May 1945 victories in Europe were celebrated in May (and later for VJ Day in August) by services of thanksgiving at the cathedral, dancing in Town Hall Square, bonfires, and street parties. Union Jacks fluttered everywhere from buildings or in the hands of revellers, but just as prominent in most streets were the Stars and Stripes, the Hammer and Sickle and Chinese flags. Bunting, victory signs, streamers and giant notices declaring victory and captions such as 'From Dunkirk to Victory' added to the impressive displays in the streets and in shop windows. The local press reported:

> Scarcely a vehicle in the streets was without its red, white and blue. Tiny flags adorned the bicycles, big flags adorned cars, and one little car was seen sporting a flag even bigger than itself! Every child had a flag, and one horde of children raced through the streets on VE morning shrieking with delight 'The War is Over! The War is Over!' All the little girls had red white and blue in their hair, and all the little boys proudly showed rosettes and golliwogs in the national colours.
>
> There was some confusion among workers in Chester and district as to the exact time the holiday would start, some thinking they would have to wait until Mr Churchill gave the official proclamation. The result was that a great number of workers, including some at Brookhirst Switchgear Ltd., and Williams and Williams Ltd., arrived at their work on VE morning only to find that there was a holiday. Those who had come some distance had difficulty in getting home, because of lack of transport, and their Victory lunch had to consist of sandwiches as on any other working day. Although streets were crowded on Monday, there were no excited demonstrations except for one or two games of ring-a-ring of roses on the Town Hall Square.

That afternoon, great numbers attended the numerous church services to give thanks and pray for those still involved in the conflict, while for many it would be August before they could celebrate VJ Day and the complete end of the war.

CHESTER GIVES THANKS AND REJOICES

City A Gay Picture With Flags And Bunting On VE-Day

SERVICE IN CATHEDRAL

CHIEF CONSTABLE'S TRIBUTE TO BEHAVIOUR OF CROWDS

THE unconditional surrender of Germany was celebrated fittingly in Chester on Tuesday, VE-Day.

The city was a city of smiles, and the great tidings, coming on Monday, gave citizens ample opportunity to bedeck their houses and business premises for victory.

The Cheshire Regiment and The Royal Welch Fusiliers have fought in Europe from D-Day to final victory.

The Chief Constable of Chester (Mr. T. C. Griffiths), tells us: " The police are very satisfied with the behaviour of the crowds on Victory Night. Having regard to the occasion, they were very well-behaved and good humoured."

toast was proposed to the men from the district who are serving in the Forces The party was arranged by Mrs. M. Woods, of Steele-street.

NEWTON CELEBRATIONS

On Wednesday the children of Well-lane were given a party by the residents to celebrate victory. A committee was formed and in the few days available they organised a programme which was packed full of entertainment. A meal was provided for 40 children and their parents, followed by singing and games for which prizes were given. The celebrations ended with the lighting of a bon-fire on the top of which the children had placed an effigy of Hitler The expenses were met by subscriptions made by the residents, and from a balance in hand the children will be entertained at the Upton Gymkhana on Whit Saturday.

A Victory tea was held at the sports ground. Long-lane (by permission of Brookhirst Switchgear) on Wednesday The tea was organised by the residents of the Ethelda Park Estate, and over sixty children were entertained Mr. Jones-Lloyd lent a pony for rides round the field. Other attractions were "Marrier v. Single" at cricket and football, children's sports, and boxing. Miss Payne gave ice-cream, and all residents helped by providing a tea.

1,000 MEALS SERVED TO TROOPS

The War Services Women's Club served free food and beer to the troops from 10 a.m. to 9 p.m on VE-Day About 1,000 meals were served and all the voluntary helpers attended.

V-DAYS AT LITTLE ST. JOHN'S

The congregation of Chester's smallest church was ready for the long-expected day, and the thanksgiving service on Tuesday was attended by Sisters of St. John's Hospital, including Miss A Turner Booth, senior sister, and scouts of Chester 32/33 Scouts in uniform. The Vicar officiated. The music was arranged by Mr. R. H. Smith, deputy organist, and Mr. J. Wakefield, cantor, and the

The local press reports of the VE Day celebrations.

LOST.—Will anyone finding a large UNION JACK, in Frodsham Street, on V-Day morning. please return, for sentimental reasons, to Mrs. Pryce, Butcher, Frodsham Street, Chester.

By the evening, however, the streets were full of jubilant revellers. Many public houses were so full that customers stood outside or sat on the steps of the Rows with their glasses and toasted the passers-by. Boys and girls linked arms and marched down the streets singing at the tops of their voices, while others danced the hornpipe, lit off crackers, weaved uncertainly from side to side, or just stood to laugh at the antics of those losing their inhibitions in the merry atmosphere. Some soldiers had the bright idea of wheeling the Royal Infirmary barrel organ

In Aid of the

Soldiers,' Sailors' and Airmen's Families' Association

A Grand Ve

Non-Stop Dance

will be held at the

Chester Castle Gymnasium

To-day (Saturday), May 12th, 1945

from 7 p.m. to 11 p.m.

Two Bands

Bernard Snook and his Blue Rhythm Dance Orchestra.

Al Powell and his Rhythm Aces.

Refreshments at Moderate Prices

Bar ———— *Ices*

Tickets 4/- each (Strictly by Ticket only)

from J D. Siddall, The Cross, Chester;
or Lieut. T. J. Morgan, 53, Watling Crescent, Handbridge.

———

This Announcement appears in this position through the courtesy of Browns of Chester, Ltd., who are defraying the cost of the space.

Non-stop dancing for local servicemen and women and their guests to celebrate VE Day.

through the city and collected quite lot of money. Whether it was for the hospital or to refuel pint glasses, no one seemed to know or care. Meanwhile in Eastgate,

> The Rows supported a deep fringe of people, all leaning over the rails and watching the fun below; the men and women careering wildly wearing one another's hats; soldiers snatching civilian trilbys and bowlers and wearing them with a more than rakish air; the Americans joining in the revels with a slightly puzzled air at this lapse from dignity of the aloof Britishers, and the policemen, both military and civil, beaming on the crowds and indulgently watching this outcome of high spirits.
>
> *Cheshire Observer*, 12 May 1945

At about 8.30 that night people began to stream up Northgate Street to hear a public broadcast of the king's speech, and there was a deep hush as his majesty's voice was heard. In the hotels and public houses the radio was turned on, and everyone rose with one accord as the band played the National Anthem.

> After the King's speech the fun became fast and furious. Mr Claude Crimes drove his loudspeaker van through the streets relaying dance music, so that every road became a ballroom on its own. As darkness fell, some of the private houses and the Odeon Cinema switched on their floodlights. The bangs of crackers became louder and bonfires glowed brightly through the night the flames outlining the prancing figures around them. The celebrations went on until the early hours of the morning, when the last rejoicing stragglers wended their way home, having taken part in a real Victory Day.
>
> *Cheshire Observer*, 12 May 1945

The following day, people took to the streets yet again, although the celebrations had begun to wind down, and celebrations were centred in the main on the numerous street parties and functions held in local community centres and church halls.

Attention had already turned to post-war priorities for Chester and included improved housing, education and town planning, plus the restoration of the Watergate Street Rows. By then German prisoners of war were already preparing the site at Blacon for the first post-war council housing estate. The Army had maintained a camp in south Blacon, throughout the war. A mixture of wooden and Nissen huts were occupied by soldiers until the late 1950s, and the army firing range was still in evidence until the tower block buildings of the mid-1960s.

Close by, Blacon Cemetery was laid out in 1940, and the cemetery's first interment took place on 20 December 1941. The cemetery contains the war graves of 461 Commonwealth service personnel, including an unidentified Royal Air Force airman, and ninety-seven war graves of other nationalities (eighty-six are Polish servicemen from various hospitals in the area) that are maintained by the Commonwealth War Graves Commission. The plot in Section A was a Royal Air Force regional cemetery for air personnel from bases in Cheshire and neighbouring counties, while members of other armed services were buried in Section H.

Second World War memorial commemorating the 22nd (Cheshire) Regiment, Chester Cathedral.

Aerial view over Chester in the 1960s, with the Ministry of Defence H-shaped Western Command building overlooking the Dee in the centre.

For those that had survived, returning servicemen and women had a better chance of living in homes fit for heroes than their First World War counterparts, although some may have had to put up with temporary prefab homes first, such as those laid

out on the new developments at Blacon and Lache. The new housing programmes, of which there were several in and around Chester, would be swiftly followed by the national legislation to aimed at rebuilding a better Britain. The 1944 Education Act was already on the statute book, but the Labour government's landslide victory in 1945 was very much about creating a new deal for returning servicemen and women, giving them a sense that their country had been worth fighting for and would support and care for them in peacetime by offering them and their families the opportunity for jobs, homes, education, health and a standard of living of which they could be proud.

It was to be a brave new world.

Bibliography

NEWSPAPERS

Chester Observer
Chester Chronicle
Chester Courant
Birkenhead News
Liverpool Daily Post
Liverpool Echo
Liverpool Evening Express
Llangollen
London Gazette Supplements (medals/honours/citations)
Wallasey News

PUBLICATIONS

FIRST WORLD WAR

Barr, Ronald J., 'The 1st Battalion 22nd (The Cheshire) Regiment and the Reasons for the Military Disaster at Mons', *Cheshire History* No. 35 (1995/96)

Chambers, Susan, *Chester in the Great War (Your Towns and Cities in the Great War)* (Pen & Sword, 2015)

Churton DSO., Lieut.-Col. W.A.V., *War Record of the 1/5th (Earl of Chester's) Battalion, The Cheshire Regiment 1914–1919* (1919, rep. 2009)

Crookenden, A., *The History of Cheshire Regiment in the Great War* (1920)

Curtis, Ann Marie, *A War-Torn Chester Parish: St Werburgh's Before, During and After the Great War* (2017)

Harris, Brian, *Cheshire at War, 1914–18: Chester Armistice Remembrance Week, 4–11 Nov. 1978* (1978)

Honingsbaum, Mark, 'Regulating the 1918–19 Pandemic: Flu, Stoicism and the Northcliffe Press,' *Journal of Medical History* vol. 57 (2), (2013), pp. 165–185 (Cambridge University Press, 2013)

Longbottom, Frederick William, *Chester in the Great War* (1920)

Rigby, B., *Ever Glorious: The Story of the 22nd (Cheshire) Regiment, Vol 1* (1982)

Royden, Mike, *Merseyside at War* (2018)

Royden, Mike, *Wirral at War* (2019)

Royden, Mike, *Village at War: The Cheshire Village of Farndon During the First World War* (2016)

Simpson, F., *Cheshire Regiment; the First Battalion at Mons and the Miniature Colour* (1929)

Simpson, F., *The Chester Volunteers (3rd Volunteer Bn, The Cheshire Regiment 1914–1920)* (1922)

SECOND WORLD WAR

David Bailey, *610 County of Chester Auxiliary Air Force Squadron, 1936–1940* (2018)

Barfield, Norman, *Broughton: From Wellington to Airbus* (2001)

Barr, Ronald, *The Cheshire Regiment* (2000)

Emma Stuart and Michael Lewis, *What Did You Do in the War Deva?: Chester District in World War II* (2005)

Ferguson, Aldon P., *A History of Royal Air Force Sealand* (1978)

Thompson, Dave, *I Laughed Like Blazes: The Life of Private Thomas 'Todger' Jones, VC, DCM* (2002)

Unknown Author, *Discovering Wartime Cheshire 1939–1945* (1985)

ONLINE

National Heritage List for England (Scheduled Monuments List): www.historicengland.org.uk

National Record of the Historic Environment (NRHE) (Historic England): www.pastscape.org.uk

Revealing Cheshire's Past (Cheshire Historic Environment Record): http://rcp.cheshire.gov.uk

Van Horssen, Dr Jessica, *Diverse Narratives*, www.diversenarratives.com (Univ of Chester) (forgotten experiences of minority groups in Cheshire from 1914 to 1918)

Chester Wiki: http://chester.shoutwiki.com

Howe, Steve, Chester: A Virtual Stroll Around the Walls: www.chesterwalls.info

BBC People's War: www.bbc.co.uk/history/ww2peopleswar

The Cheshire Military Museum: www.cheshiremilitarymuseum.co.uk

The Cheshire Archives and Local Studies Service Archives: www.cheshire.gov.uk

Cheshire Image Bank: cheshireimagebank.org.uk

For excellent information and images regarding urban exploration and the bunkers below Western Command, see 28 Days Later: www.28dayslater.co.uk

North West Exploration Forum: www.nwex.co.uk

Acknowledgements

The author and publisher would like to thank the following people/organisations for permission to use copyright material in this book:

Nora Gauterin

Grosvenor Museum, Chester

The Cheshire Archives and Local Studies Service

Cheshire West and Chester Council

Chester History and Heritage

University of Chester

Every attempt has been made to seek permission for copyright material used in this book. However, if we have inadvertently used copyright material without permission/acknowledgement we apologise and we will make the necessary correction at the first opportunity.

The author would also like to thank Nick Grant and Jenny Stephens at Amberley for their help and guidance; Peter Jones and Tony Wainwright, fellow members of Everton FC Heritage Society, who have a great depth of knowledge of both wars;

Peter Gauterin and his mother Nora, for permission to use extracts of interviews and her unpublished memoir; Lewis's Café, Farndon and their wonderful staff — Alison, Nicky, Nikki, and Jen; and as always, Liam for all the support, and Lewis for the help with photographs and illustrations.

About the Author

Mike Royden has taught History for over thirty years, and has also lectured on numerous courses in local history in the Centre for Continuing Education at the University of Liverpool. He has written several books, and has made regular appearances on radio and television including Radio 4's *Making History* and BBC's *Heirhunters,* as well as filming with Hollywood star Kim Cattrall discussing her Liverpool roots for *Who Do You Think You Are?* He also appeared on the programme featuring Gareth Malone in the same series, and with Ricky Tomlinson in *Blitz Cities.* He has also researched extensively into the history of the First World War and has led tours on the Battlefields of France and Flanders. In 2017 he was elected as a member of Everton FC Heritage Society. Mike Royden also runs several history websites at www.roydenhistory.co.uk.

He has two sons: Lewis, who is a photographer; and Liam, a musician.

Titles by Mike Royden:
Merseyside at War 1939–45 (2018)
A-Z of Chester: People, Places, History (2018)
Tales from the 'Pool: a Collection of Liverpool Stories (2017)
Village at War: A Cheshire Village During the First World War (2016)
Liverpool Then and Now (2012, 2nd edition 2015)
Tracing Your Liverpool Ancestors (2010, 2nd edition 2014)
Did Adolf Hitler Visit Liverpool in 1912/13? – BBC.co.uk website (Legacies)
A History of Liverpool Maternity Hospital and the Women's Hospital (1995)
A History of Mill Road Hospital, Liverpool (1993)
Pioneers and Perseverance: A History of the Royal School for the Blind, Liverpool, 1791–1991 (1991)

Forthcoming:
Wirral at War (2019)
Sails, Shipwrecks and Suffragettes: A History of Thomas Royden & Sons, Liverpool, Shipbuilders (2019)